DOROTHY CROSS

Irish Museum of Modern Art

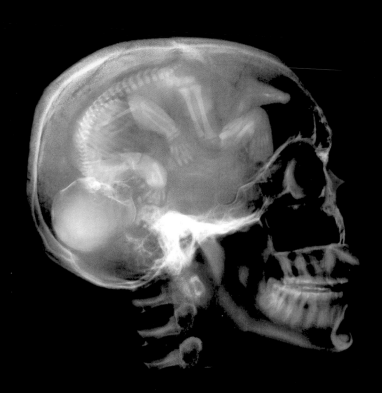

CHARTA

DOROTHY CROSS

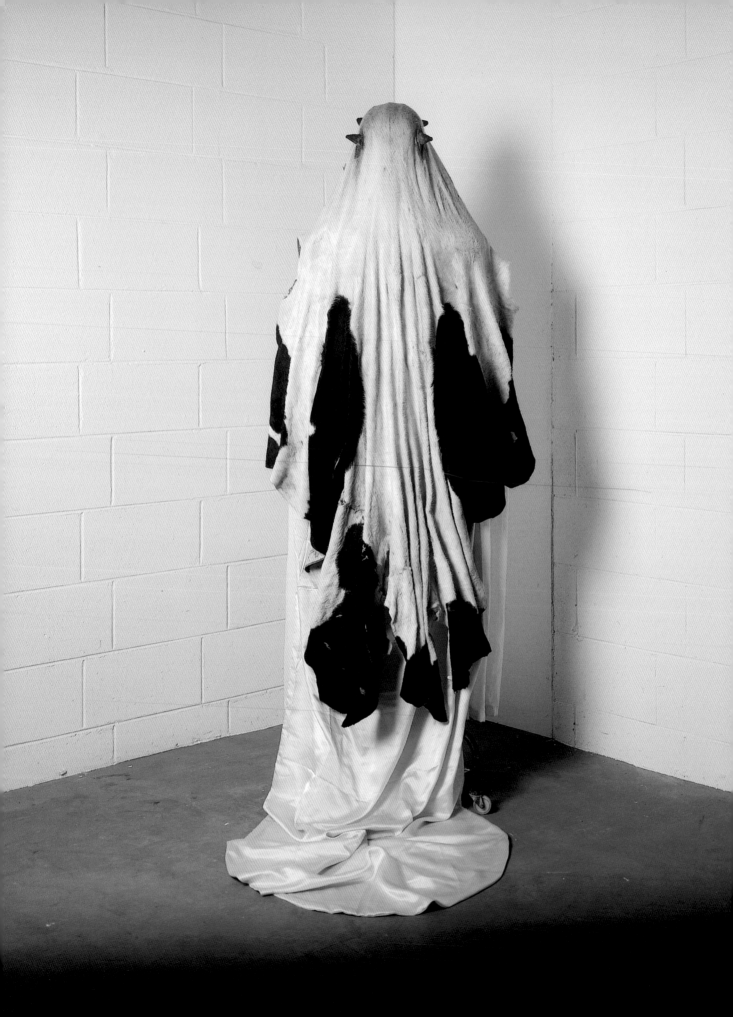

Foreword

This monograph marks the first substantial exhibition of Dorothy Cross's work at the Irish Museum of Modern Art, Dublin. Dorothy Cross is one of Ireland's leading artists, with a long established international reputation, and it is therefore timely that such a significant exhibition and publication should take place.

The art of Dorothy Cross is a poetic amalgamation of found and constructed objects, sometimes humorous, sometimes disturbing, always intellectually stimulating and physically arresting. Since the mid-eighties, working in a variety of media including sculpture, photography, video and installation, Cross has conducted witty and inventive investigations of contemporary sexual mores and politics. During the nineties she produced two extended series of sculptural works, using cured cowhide and stuffed snakes respectively, which drew on these animals' rich store of symbolic associations across cultures to investigate the construction of sexuality and subjectivity. More recently, Cross has devoted increasing amounts of time to the development of large-scale public events and projects, most memorably the award-winning *Ghostship* and *Chiasm*.

The Irish Museum of Modern Art has had a long relationship with the artist, from early acquisitions to our collection, to inclusion in the important exhibition *Irish Art Now: from the Poetic to the Political*. This then led to the pioneering and beautiful collaboration that took place between 1998–1999 when Cross was selected to produce *Ghostship* as part of the IMMA / Nissan Art Project award. *Ghostship* was an ethereally illuminated light-ship that haunted Dublin Bay for a number of weeks in 1999. It was a wonderful project that lives on in popular memory in the city of Dublin and beyond, and it is documented in some detail in this book.

Significantly, this exhibition forms part of a strand of programming at IMMA that aims to produce defining mid-term retrospectives of Irish artists of international repute. This series has included artists such as Kathy Prendergast and Willie Doherty. Cross is an artist whose work I have been following for a number of years now, and so I welcomed this opportunity to develop a project with her.

I would like to take this opportunity to thank everyone involved in the organisation of the exhibition. At IMMA my thanks go to Seán Kissane, who has worked closely with the artist to produce this exhibition. To the Kerlin Gallery, Dublin and Frith Street Gallery, London for their on-going support. To the authors of the catalogue, Marina Warner, Patrick Murphy and Ralph Rugoff, for their essays that greatly extend our appreciation and understanding of Cross's work. To Giuseppe Liverani and his team at Edizioni Charta for producing such a beautiful book. To the institutions who lent works from their collections: Tate Gallery, London; The Hugh Lane Municipal Gallery, Dublin; The Ulster Museum, Belfast; Artpace, Texas and the various private collectors who wish to remain anonymous.

Finally my heartfelt thanks to the artist for her friendship and her gracious and generous commitment to this project.

Enrique Juncosa
Director

6

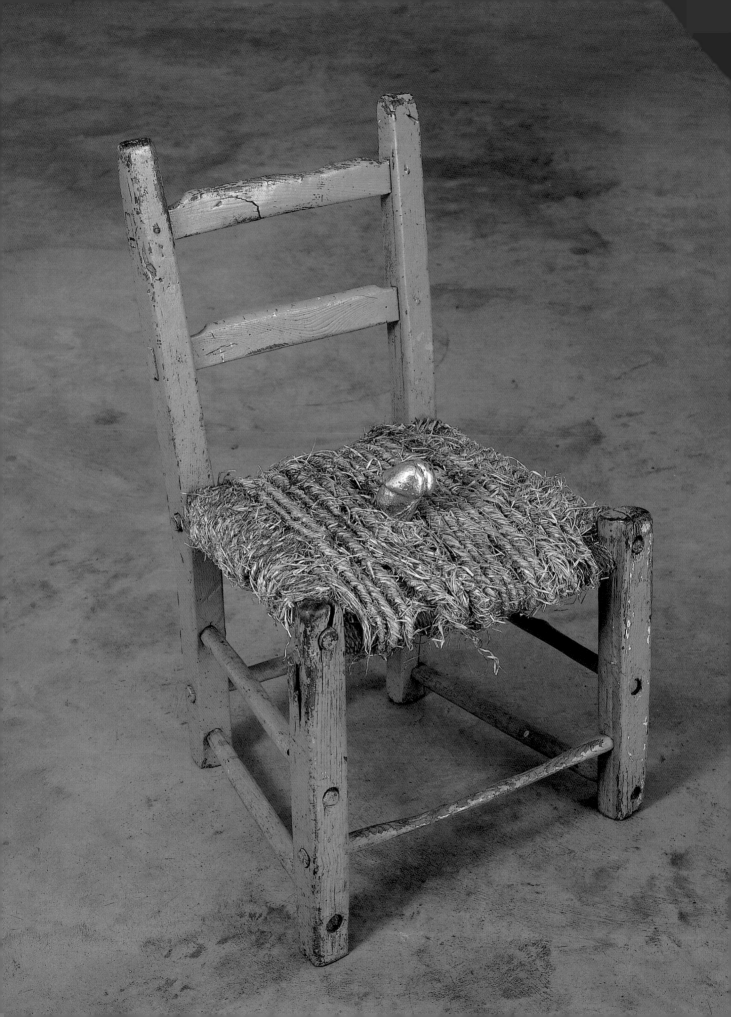

Contents

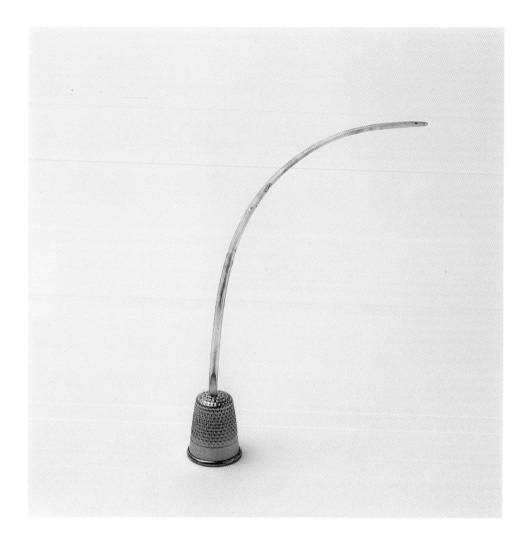

A Theory of Seeing

Enrique Juncosa

*"I know the way she went
Home with her maiden posy,
For her feet have touch´d the meadows
And left the daisies rosy"*

Alfred Lord Tennyson

The work of Dorothy Cross, like that of many contemporary artists, cannot be described as a linear progression of formal refinements but, more appropriately, as a series of groups of interrelated works. Cross uses a variety of media to create her work, from sculpture to video, photography to installation and musical performances. She uses these media in a variety of formats, scales and modes of presentation. Certain elements remain constant throughout her artistic output that bring to mind subjects such as Surrealism, eroticism, Feminism and psychoanalysis when discussing her work. I shall attempt to describe here these recurring elements or themes in a brief synopsis of her career, beginning with the works that Cross produced towards the end of the eighties.

The sea, seen as an outward manifestation of the depths of our subconscious, forms the backdrop for many of her works; as do various aquatic creatures such as sharks, whales and jellyfish. The transformation of these symbolically rich creatures is typical of her work, offering simultaneous, often conflicting readings. Cross's works seem to analyse emotions like desire, while urging the viewer to question appearances, stereotypes and the social conventions and superstitions that one associates with them. Her works are not destructive or nihilistic, but rather show a wish to seek out the very essence of things, while analysing along the way, the manner in which we perceive them. So we are not what we think we are, nor how we would like to be seen, and the simple act of looking can be a moralising or political act in itself.

The earliest work in the current exhibition is *Shark Lady in a Ball Dress* (1988). This anthropo-morphic sculpture formed part of a group of interrelated works in *Ebb*, an exhibition that took place in Dublin's Douglas Hyde Gallery. The very title of the exhibition suggests the submerged currents that psychoanalytical questions attempt to unveil. Joan Fowler's broad study in the *Ebb* catalogue placed the works in the show within the context of certain theories found in the writings of Jung, Freud, and various feminist writers. *Shark Lady in a Ball Dress* lends itself comfortably to a humorous, figurative reading; in fact in the photos of the show, the works look like puppets or wind-up toys moving about a stage. However, on closer inspection, the works seem to encourage us to dig for those more intimate questions that are often buried deep in our subconscious.

Shark Lady, as the title suggests, represents a shark in a woven bronze ballroom dress, the form of the shark uncannily phallic. The figure's breasts can be read as testicles, while the dorsal fin has something angel-like about it. The work as a whole is somewhat grotesque, yet it is also warm, gentle, and witty. It implies that a woman "dressed to kill" is perhaps not simply an object of passive desire, but like a shark, both the male and female of the species can suddenly turn on us—with potentially devastating consequences. In the same way that the sight of a shark fin in the sea makes unknown dangers spring to mind, surrendering to desire can take us with astonishing speed to unexpected places.

It is fair to say that all of the works gathered together in *Ebb* initially provoke a humorous reaction, but they soon raise complex symbolic associations that have a lot to do with sexuality. Many of the figures can be read as male or female. They are powerfully evocative works that are impossible to read in a single way—they deal with physical and spiritual questions, day-to-day realities, and the world of dreams, the symbolic and the descriptive. Many of the works in this particular group form

11

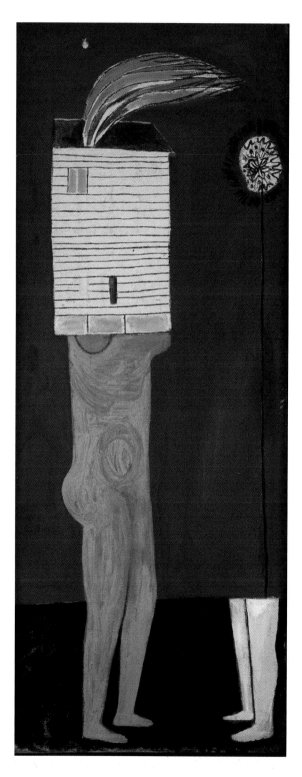

pairs, others suggest anthropomorphised dwelling places (one thinks of Louise Bourgeois's famous *femme-maison*) where selected scenes from married life are acted out.

A wide range of materials is chosen, from bronze and wood, to found objects. These works suggest that psychoanalytical concepts are present, both in the works and in the materials used in their creation. Therefore, we can view these works as visual translations of ideas into three dimensions, complex and at times impenetrable. The exhibition space becomes a stage set where these strange performers act out multiple, shifting ideas. The barramundi, an Australian freshwater fish, changes its sex during its lifetime, as some of these sculptures also seem to do. They remind us of that famous image, beloved of psychoanalysts, of the rabbit that is at the same time a duck, which has fascinated many figures from Ludwig Wittgenstein to James Coleman to Jasper Johns.

Cross's 1991 exhibition, *Power House*, took place in the ICA Philadelphia and included works such as *Passion Bed* (1989) and *Screen/Ladies Changing Room* (1991). In pieces like *Kitchen Table* (1991), Cross revisited ideas explored in her earlier work. The works from this exhibition referred to everyday objects used in the home or in the workplace. Once again, we find that these items quickly acquire a symbolic force that refers (although not exclusively) to sex and death, but also to strength and vulnerability. The surface of *Kitchen Table* is infested with burnt impressions of sharks that suggest subterranean (or submarine) forces and currents. In the centre of the table, there is a bowl with worn, rusted holes positioned above an upright test tube filled with fossilised shark teeth. The test tube sits on a curved shelf, ready to burst through the table like the arrow in a drawn bow. In this way, the table has both male and female attributes. It is this use of the quotidian, the combination of a table and a bowl that implies that sexual desire is

always present and we can be slaves to our carnal impulses. The burnt sharks on the table's surface transform this concealed but commonplace anxiety into ornament, suggesting perhaps that it is desire itself that drives Cross to create art.

Passion Bed is a fragile wire structure that contains in its upper section thirty wine glasses onto which shark images have been sandblasted. The structure is reminiscent of a cage, or the enclosed chapel space where one lights a votive candle in a church, suggesting the enticing temptations of passion and offers of sex.

Screen/Ladies Changing Room, on the other hand, is a folding screen that the artist found in her studio in the disused, Poolbeg Power Station. The screen was drilled with holes through which one can see a line of bronze hard hats, topped with cast nipples. The work gives a strong erotic charge to a workplace—like a changing room in a factory. The breast-shaped helmets transformed into bronze present a protective device for the workers' heads in the territory of the powerhouse.

The peepholes suggest that notions such as these dwell in secret, intimate places, or that their sources can be found in those hidden areas of the psyche. They also suggest the private worlds that exist within public or social places, and of the constant presence of desire and its ceremonial or ritual possibilities. The use of worn, used materials in the creation of these works suggests the constantly shifting nature of memory, while emphasising its fragility. The peepholes remind the viewer that their view is obscured—both literally and metaphorically.

From 1992 to 1995, Cross created a series of works using cowhide, entitled *Udder* (the pronunciation of which can sound like *other*). This series of works calls to mind Meret Oppenheim's famous fur teacup, bringing together the animal and the domestic. The udder works have something totemic about them and refer to dreams, desires and archetypes. The udders suggest, primarily, nurture, but here they are used to cover objects such as sports equipment in the case of *Croquet* (1994) and *Saddle* (1993); shoes in *Stilettos* (1994); and a Guinness bottle in *Pap* (1993). These paradoxical combinations lend these works great expressive strength. Sometimes there are direct references to sex, where the teat appears phallic, as in *Amazon* (1992)—a mannequin with a single teat that takes on an aggressive, militaristic quality. The sexual imagery of fetishism, which fascinated the Surrealists, forms the underlying landscape for these works.

In *Virgin Shroud* (1993), the cowhide forms a draped cloak. The work reminds us of the Virgin Mary or of representations of female saints, however, we cannot in this case be certain of the sex of the cloaked figure. The udder has been placed on the head, as if the teats were horns, causing the figure to become a sort of outlaw, more animal than spiritual. The work is not a representation of a figure in ecstasy; its head does not suggest the presence of an intellect or spirit. The work reminds us, perhaps, of the limitations of our own physical body, whose bulky mass remains firmly rooted in the earth however much we might like to transcend it. The figure's gender remains undetermined, but

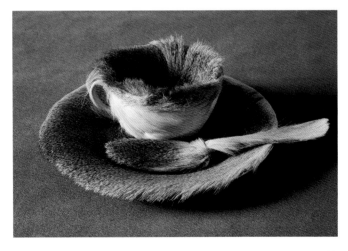

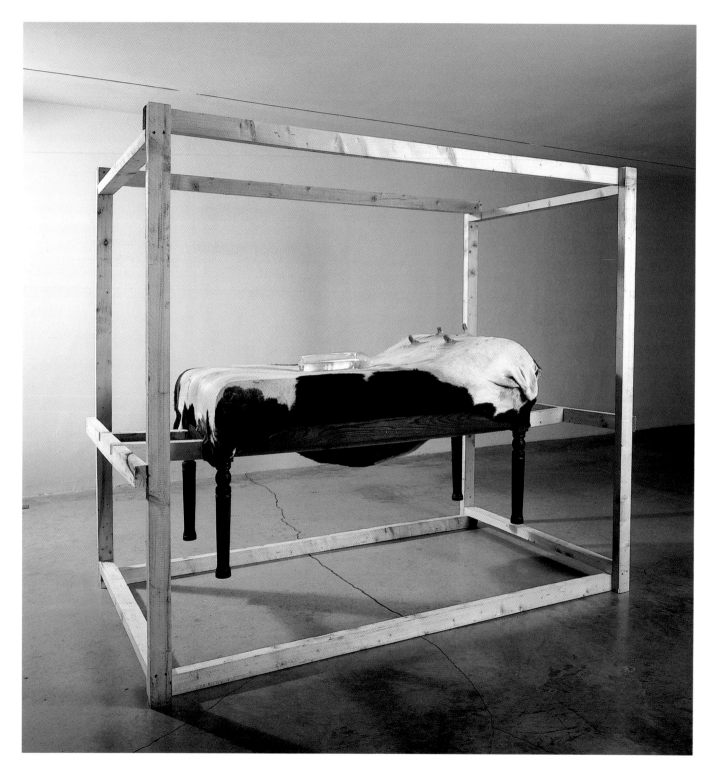

neither does it conjure up ideas of nurture or motherhood. *Trunk* (1995), the last of Cross's works to make use of cowhide, consists of a cow's udder sewn to the inside of a pair of knickers that are semi-concealed inside a wooden trunk. The work deals with the hidden and the private, bringing to mind anxiety, pleasure and masturbation. The nature of the milk-giving teat here is changed to a phallic one, into a form that some find repulsive and some desirable. *Trunk* was exhibited in *Even* (1996). In this exhibition, Cross explored religious and sexual themes, in such works as *Bible* (1995) and *Mantegna/Crucifix* (1996). In the former work, a Bible had a large hole drilled through its centre while the prostrate figure in the latter work was that of a naked woman. In *Iris* (1994), Cross used a cast of a silver flower and in *Untitled* (1995), a skull, both of which suggest the concept of transience. The petals of the flower in *Iris* refer to the female, but they sprout from a rhizome root in the form of the male sex organ, which indicates interdependence in addition to temporality.

The most substantial group of works from this period use snakes—a symbolic creature that is simultaneously beautiful and repellent. Across various cultures, snakes represent death and destruction, but also resurrection and the cycle of nature. It is said that St. Patrick, the patron saint of Ireland, drove the snakes out of Ireland; it would seem that Cross wants to re-introduce them as metaphors of transgression. In *Lover Snakes* (1995), we see two intertwined snakes, whose heads meet to form the shape of a heart. Between them, two reliquaries, cast in silver, contain their actual hearts. Here Cross presents something that is poignant, but also disturbing. *Kiss* (1996), a slightly later work, is a silver cast of the shape formed when a couple kissed with modelling material in their mouths. It depicts one of the most carnal aspects of this display of affection, when our moist tongues coil around each other like snakes, but the resulting

object is like a bone, like the death of a kiss. At this point in her career, Cross's work becomes particularly diverse, suggesting that the techniques she uses at any one period are simply a means to an end. Among works from this period are photographs of the clashes between rugby players and a rugby ball. These works concentrate on small details, especially the movement of the players' hands. Captured thus, they transmit feelings of tenderness and affection and remind us of the thick folds in the robes of figures and limbs in Baroque paintings. They are not celebrations of virility or physical force, but are the result of an erotic feminine gaze. The images play on another of the artist's themes, the idea of vulnerability within strength. The ball becomes the focus of each photo, looking like an egg that must be shielded from danger at all costs.

In the second half of the nineties Cross began to work with video. In *Teacup* (1997), the first of her video works, we see a scene from *Man of Aran*, Robert Flaherty's thirties documentary about the constant daily fight for survival of fishermen from the Aran Islands, projected inside a teacup. The contrast between the raging sea and the fragile boat tossed upon it, and the calmness normally associated with a teacup emphasises that something extreme can be commonplace. *Snake* (1997) is the title of the artist's second video work in which we see a snake crawling towards us. The video is displayed in a hole in a wall—the black snake first appearing like a pupil of an eye. This may suggest that there are things inside us that we find fascinating and frightening at the same time.

Other video works that followed were more ambitious in scale, employing opera singers, music, and large sets constructed or found in nature, for example *Ghostship* (1999), *Chiasm* (1999) or her more recent collaboration with the Opera Theatre Company, a performance of Pergolesi's *Stabat Mater* in a quarry on Valentia Island, Co.

Kerry. Each of these works is quite different. For *Ghostship*, she painted an abandoned lightship in Dublin's Dun Laoghaire harbour with phosphorescent paint. For three weeks the boat was illuminated for a period and then left to glow in the darkness. Every night, Cross recorded the progressive decay of the boat's luminescence as it was slowly swallowed up again by the surrounding darkness. In *Chiasm*, Cross projected the image of a natural sea pool formed by tides on the coast of the Aran Islands into two abandoned handball alleys, separated by a dividing wall. In each of the two handball courts an opera singer, one soprano and one tenor, sang fragments of arias from nine romantic operas. The way in which the members of the audience were positioned meant that is was just as impossible for the audience to see the entire performance from any single vantage point as it was for the doomed lovers to avoid their fates.

Eyemaker (2000), one of her most interesting videos, is a film of the construction of a glass eye. The camera relishes the entire process from beginning to end, treating the subject with the same care and attention employed by the eyemaker himself. At the final moment of completion the eyemaker blows into his glass tube and the eye shatters, exposing the artifice of this replica of the organ of vision. This seemingly innocent process becomes an allegory of the role of art for Dorothy Cross—leading us to question artifice and truth.

From 2001, Cross returned to her earlier fascination with sea creatures by investigating the semantic and symbolic possibilities of the jellyfish. Cross dried various species of jellyfish on paper and linen, these works are like drawings, allegorical still-lifes. The resulting images are reminiscent of dried flowers, but when placed upon bed linen, they become the stains from nocturnal emissions and the vague remnants of unsettling dreams.

Her most ambitious works with jellyfish to date are the videos *Come into the Garden Maude* (2001),

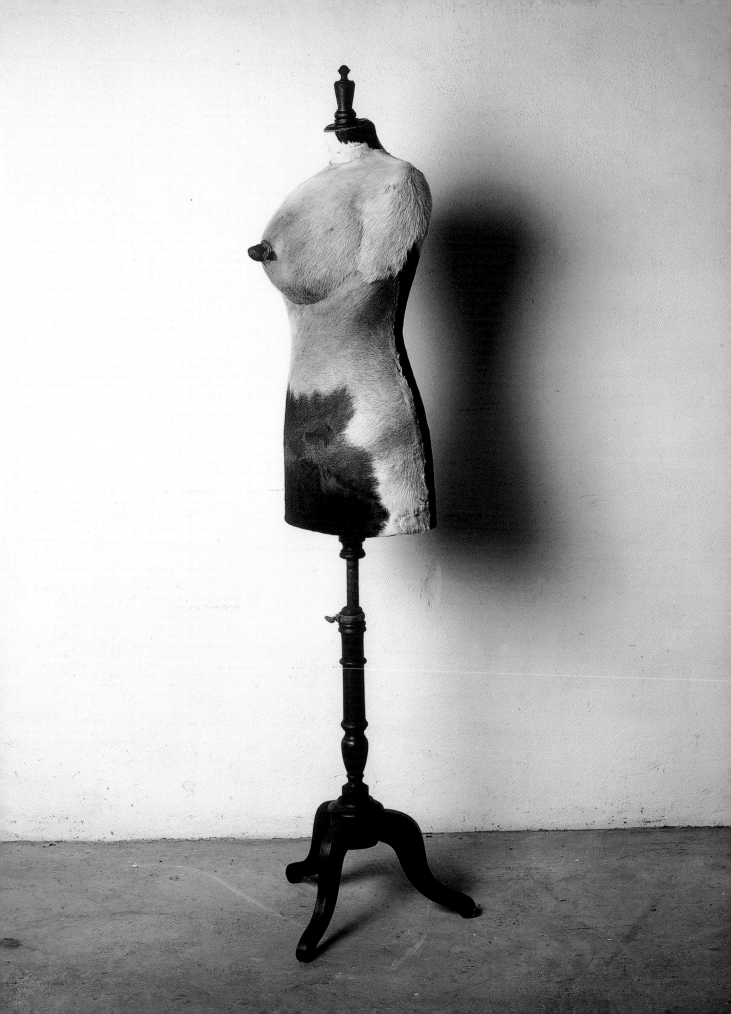

Pointing the Finger
1994

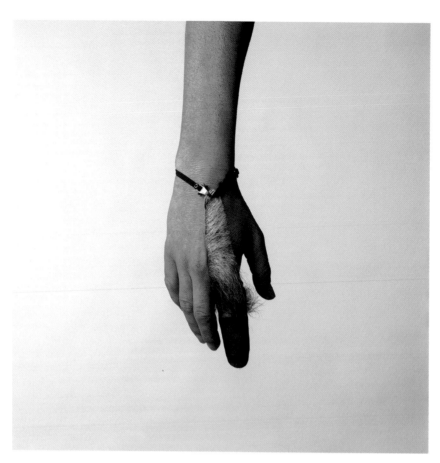

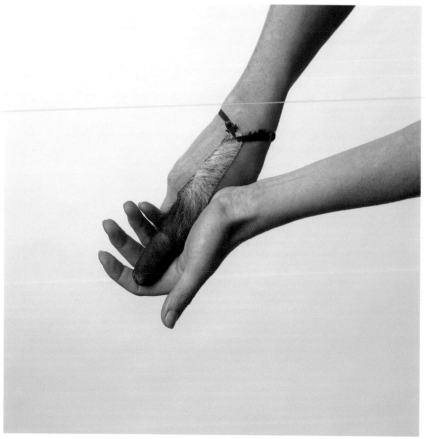

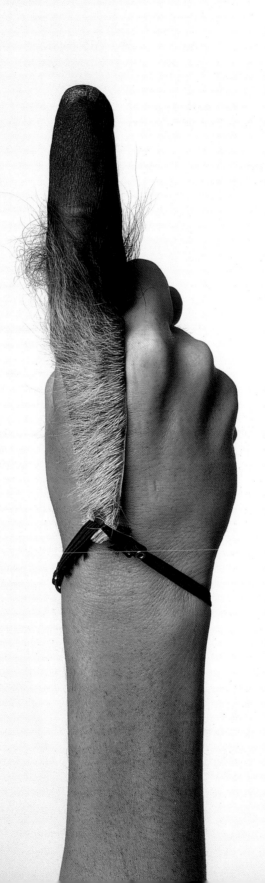

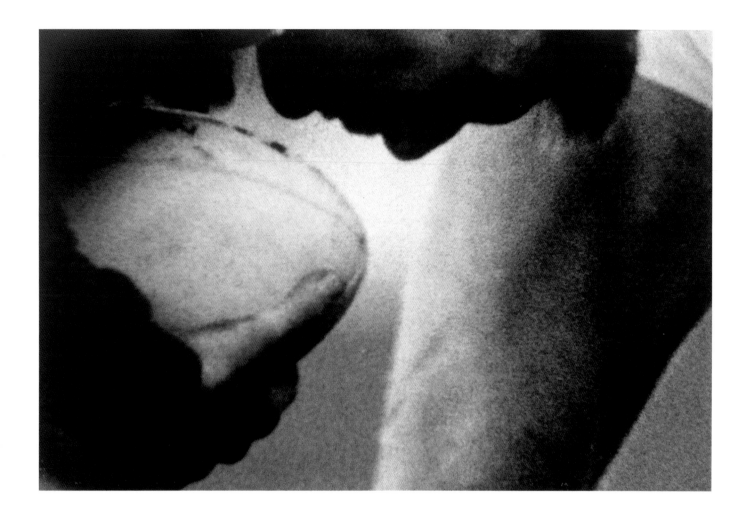

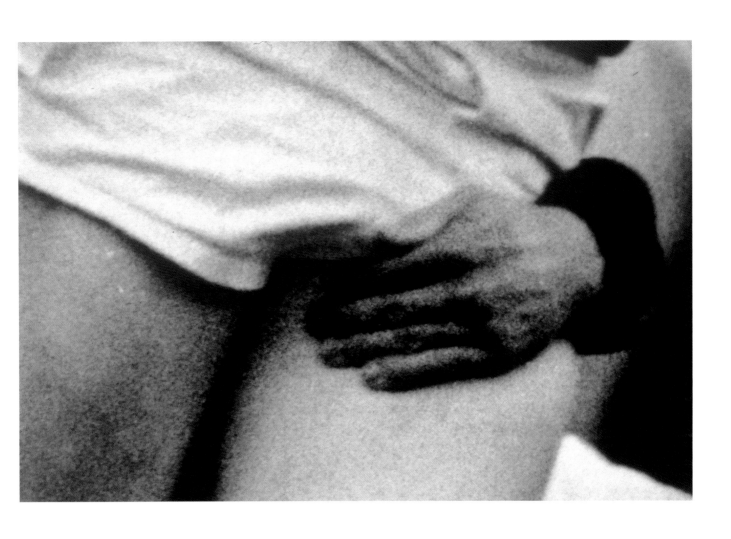

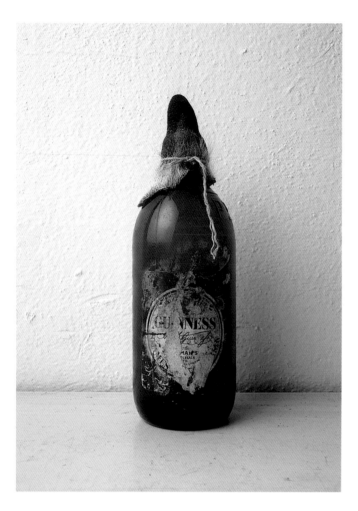

Jellyfish Lake (2002) and *Medusae* (2003). The three are the product of a collaborative project on jellyfish with her brother Tom Cross, a professor of Zoology at University College Cork. Dorothy Cross researched the life of the nineteenth-century Irish amateur naturalist, Maude Delap, whose fascination with jellyfish led her to study and eventually breed them in captivity in her house on Valentia Island. Meanwhile, Tom Cross studied the scientific aspects of these creatures and the way in which they move. Their studies brought them to Australia and Micronesia, where they encountered the *Chironex fleckeri*, a highly venomous species that can travel extremely quickly. Jellyfish are exquisitely beautiful creatures, floating with seeming weightlessness, like stars in the heavens, yet are treacherously venomous.

After this brief journey through a selection of the artist's works, it should be clear that her artistic preoccupations lie not in the creation of independent, stand-alone works of art, but rather a representation of the ideas that inhabit our subconscious. Her imagery seems to emerge from a casual encounter with objects with which she later becomes obsessed. Equally, her gaze can shift from the expanse of nature to the intimacy of the domestic.

Rosalind Krauss, a writer who is often mentioned in connection with Cross, has already situated the act of seeing, or vision, in the realm of the subconscious. For Dorothy Cross, no object has a single reading and no one interpretation is more valid than another. Her work is at once beautiful and disturbing, as are the themes that she explores. It reminds us that any absolute runs the risk of becoming dogmatic. And so, Cross tackles themes from a different angle, destroying the concept of a single dominant narrative, throwing them open to multiple interpretations.

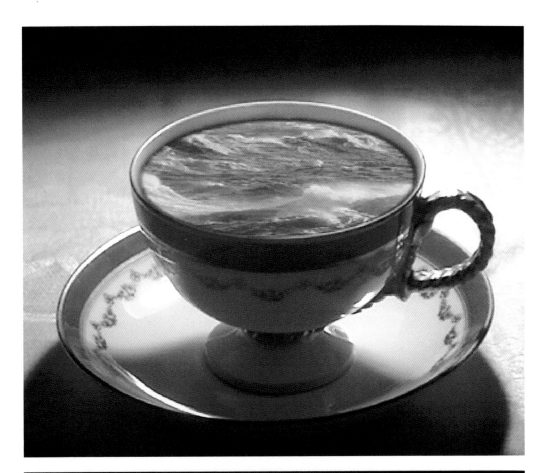

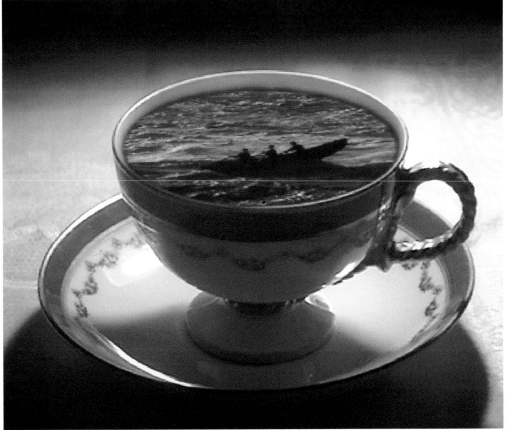

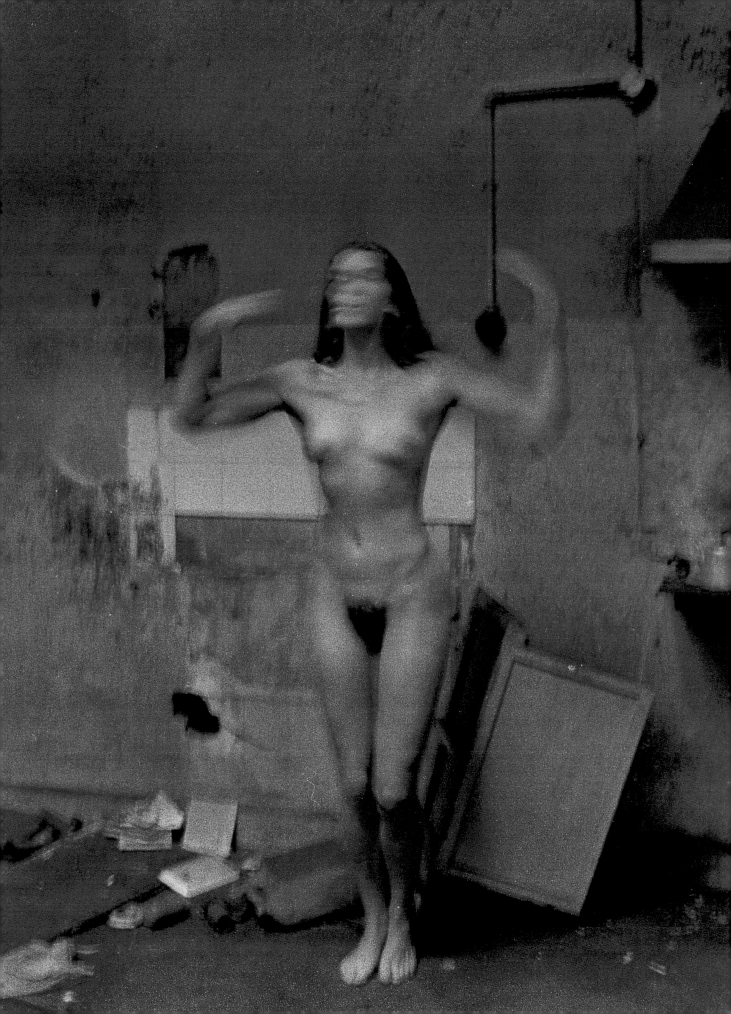

Passionate Cruces
The Art of Dorothy Cross

Marina Warner

"What's the good of Mercator's North Poles and Equators,
 Tropics, Zones, and Meridian Lines?"
So the Bellman would cry: and the crew would reply,
 "They are merely conventional signs!"

Lewis Carroll, *The Hunting of the Snark*

The slate quarry on Valentia Island, Co. Kerry was dedicated as a grotto of the Blessed Virgin in 1954, the Marian Year when the men and women of Ireland offered up their wedding rings and other treasures to crown statues of Mary with gold.[1] High up on the summit, a Lourdes group of Mary and Bernadette was set up, with a silver stream trickling from their feet and falling into a circular basin below, where a lop-sided burly pelican presides. Cast in concrete and painted all over in household gloss, this bird makes the grotto look like an abandoned children's zoo, and several people attending the performance of *Stabat Mater*, staged in the grotto last summer by Dorothy Cross, were baffled by the pelican's central presence.

The medieval emblem of the pelican imagines the bird opening a wound in her breast with her beak in order to nourish her fledglings with her blood; she became a type of perfect sacrificial motherhood. The near-grotesque image of female masochism echoes earlier points of engagement in Dorothy Cross's work—it fascinates her, but provokes spirited resistance. "Pie pelicane, Jesu domine . . . " goes the canticle, written by St. Thomas Aquinas for the feast of Corpus Christi. It is one of those bizarre Catholic typologies that enshrines the legend of the mother bird as a type of Christ's love for humanity, and thereby transforms Jesus' crucifixion into a mother's bleeding self-immolation. A sacrificial body dismembered for others to flourish, degraded and despised in order to accrue the virtue of humility, has inspired in Cross several works defying demarcation lines between purity and danger, pollution and grace. But the Pelican gives the trope a fresh twist—stripping Christ of maleness as well as humanity, and growing out of other Biblical cross-gendered images of Jesus: he is likened to Rachel weeping for her children, and to a hen clucking for her chicks—identified with a mother bird.

Over twenty years of making art, Dorothy Cross has challenged such symbols, exploring the charged conductors between flesh and spirit, and daringly, imaginatively, and often wittily recalibrating their balance so that we—her viewers—re-engage with bodies, human and animal. Her art, created in a prolific and inventive variety of material and genres—from small cast objects to operatic productions, from drawings to film—has gradually unravelled conventional signs to tease out new meanings, and made it possible to re-think our instinctive responses and glib judgements. This handling of tradition has a wild edge, touched with humour as well as pain, and it exhilarates and invigorates like the wind on the Connemara shore where the artist lives works, and walks and swims.

When Dorothy Cross was in California in 1982, she volunteered as a test subject for Jungian analysis. Jung's approach to symbols attracts her more than Freud's, as the former does not cast them as keys to an individual's past complexes and repression, but accords them a plural, polysemous vitality in "the collective unconscious". Whatever the truth-status of these contradictory currents within psychology, Jung's theories have certainly inspired numerous artists to draw deeply, in very different ways, on the reservoir of universally understood symbols (Paula Rego, notably, has been profoundly shaped by Jungian analysis). Dorothy Cross's fascination with gender-mirroring and inversion, for example, celebrates sexual ambiguity in the tradition of alchemy, which Jung explored. Alchemists desired to dissolve polarities in a *coincidentia oppositorum*: the figure of the hermaphrodite, born of the passionate fusion of the water nymph Salmacis and a beautiful youth, Hermaphroditus, embodied this ideal commingling of male and female.[2]

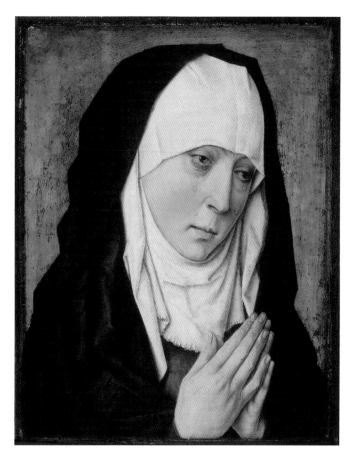

In her early works, Dorothy Cross defied standard expectations of female nature through highly condensed, often wittily punning images: *Shark Lady in a Ball Dress* (1988, the earliest piece in the exhibition) challenged the Jaws cipher of the shark as male aggressor, and called attention to the equal power, speed, sleekness and general streamlined elegance of the female of the species. Dorothy's young lady, as it were, a demure Cinderella débutante attending her first dance, looks like a phallus in a dress. Over the decade that followed, several works scuff the markers between male and female: the diptych *Mantegna/Crucifix* (1995), for example, shows a dramatic foreshortening of a woman's body, as in the Renaissance painting; the figure's pubis makes a shadow in the form of a cross, mir-

roring the absent figure of Christ on the small wooden crucifix in the other panel. From the same year, the boldest of these challenges, *Trunk*, concealed a splayed pair of used knickers with a hairy cow's teat stitched into the gusset—a kind of fantasy of a monstrous clitoris, or of masturbation, or both.

In the eighties and nineties, Cross kept up this spirited and ingenious series of challenges to the phallologocentric regime. Her treatment of the visible signs of gender—corporeal, emotional and behavioural—revealed how frequently they are inverted without anyone noticing or objecting. Photographs of "rugger-buggers" show them cradling the ball as tenderly as mothers, their own bodies touching with claspings and twinings as intimate as a passage from Edmund White or Alan Hollinghurst on gay desire. In 1993, she had a penis made in Waterford crystal, like Cinderella's fetish in some male disguise, as glacial as the devil in the fantasies of the witch hunters. When the glass workers were contemplating the result, the artist wished she had brought a video camera to film their body language.[3]

Dorothy Cross took the implications of the rugby photographs further, and covered a ball with teats, one of a famous series of works made from a cow's udder. This highly inventive sequence literally drew down (milked) a rich flow of images from the most creaturely part of the female animal's body: *Amazon, Pap, Stilettos, Spurs* show her erotic energy, a hunger for sexual knowledge, and female curiosity—all of them, incidentally, sinful in old-fashioned Catholic views about girls. But some of the most powerful are also touched by an enraged compassion for the animal, our sister, our self: *Virgin Shroud* (1993) offers the mother as matter (*mater/materia*), the female as body emblazoned. She has no face, no identity; this maiden has disappeared into biology. She is also a bride, draped in the wedding train of Dorothy Cross's maternal

grandmother under the cowhide. This is a fierce act of defiance: a bride going to the slaughter; a bride as future ghost, as in the old ballad in which a young girl sings of her wedding dress becoming her winding sheet.

Alongside many of her peers both in the United States and Europe—for example Carolee Schneeman, Kiki Smith, Helen Chadwick—Cross was also reclaiming the so-called lower senses (not vision, but touch, taste and smell) as the territory of art and as a personal field of inquiry.[4] The cow's udder, however domestic and commonplace, appears almost scandalously naked when introduced into a gallery space, its teats so vulnerably human yet hairy, animal, almost obscenely engorged, nearly comical (pantomime dame-like), a pitiful caricature of a woman's body and yet the full breast of the good mother incarnate. Without any commentary, the udders Dorothy Cross introduces, without commentary but with numerous visual puns and rhymes, stir associations both local and universal: of the foul and the sweet, the sacred cow and the poor cow, the Irish farmyard and the Magna Mater. The works in this material arouse strong, strange, shivery, pleasurable, deep and old memories of contact, smell, and taste as they confront us with the beast in our human selves. She wants her art, she says: "To relocate ourselves as animals".

Besides animal metamorphoses, transformations operate at different levels in contemporary art. When artists re-imagine definitions of themselves, cross boundaries between species, and transmute base materials, they often act to transvalue their subjects. Aesthetically and ethically, they reformulate values, and in attempting this refashioning of tradition, re-assess the inherent character of change and mutability.

In Dorothy Cross's art metamorphosis often involves intense, iconoclastic acts: in 1995 she drilled out a satisfyingly round trim hole through the centre of a Bible that was in the attic, and which her mother had given her. Similarly *Eyemaker* (2000) raptly films a skilled glassblower at work on his bench creating a perfect simulacrum of an eye, from the coloured iris to the thread veins on the white of the eyeball. Dorothy Cross first studied jewellery-making at Leicester Polytechnic, and the eyemaker's absorption and craftsmanship at his bench presents us with an alter ego of the artist. At the end of that film, however, she asked him to

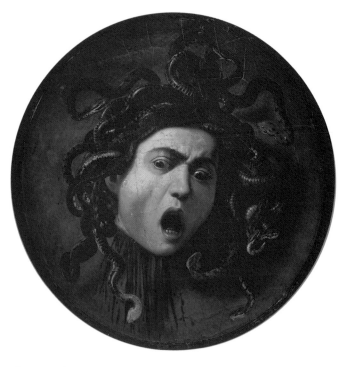

enigmatic relationship; this complex assemblage, while seeming to deface the Mother of God, breathes a hallowed mood of respect, love and awe. It is a memorial to AIDS victims and an entreaty for the cleansing waters of mercy from an artist who quarries body symbolism in a similar spirit to Dorothy Cross, in his case with the avowed intention of reconfiguring attitudes to gay experience.

Like Gober, Dorothy Cross searches out stories to enliven signs and symbols. It is interesting that the word "istoria" is related to the Greek word for inquiry, and in her case, she is making inquiries as she is making up stories. Roy Foster has described in his collection of essays, *Irish Story*, how historical negotiations of identity have inspired a sheaf of tangled, contradictory plots. Artists contributed powerfully to those narratives (Daniel Maclise's paintings for the Houses of Parliament at Westminster on the one hand, Jack Yeats recording the people, the landscape, and the customs of Ireland on the other).[6] Dorothy Cross belongs in many ways to this rich tradition of Irish self-reckoning. With a bricoleur's ingenuity, she has reattributed meaning to many of the things—heirlooms from her Cork childhood—entrusted to her by her mother in the same spirit. With *Teacup* (1996), for example, Dorothy Cross packed layers of meaning into the delicate porcelain by projecting into it footage of tossing curraghs from Robert Flaherty's film *Man of Aran* (1934), one of the earliest ethnographical films to chronicle harsh subsistence living in Europe. Combining this piece of family china, redolent of bourgeois refinement and reticence, with epic poetry on film about man's struggle with nature, the artist has compacted, most eloquently, contradictory national memories and fantasies. The leaves at the bottom of this teacup tell stories of competing nostalgias, for civility on the one hand, for salt-of-the-earth authenticity on the other. In a comparable mood, the video *Endarken* (2001) slowly eclipses a cottage with a black spot (another hole) in an elegy

destroy his work; with a slight puff, he blows it up. This breaking also breaches the illusion of art, and recalls our attention to the difference of embodied experience. The glass eye, however perfect, could not see; and besides, like all artefacts, it is fragile and even expendable when compared to the pulse of life itself and the vision of the living body.

Such disfigurements are swiftly followed up, though, by acts of imaginary restitution, the artist generously offering another symbol as a substitute: destruction becomes metamorphosis. James Conway perceptively wrote about *Bible*: "Wonders . . . ! The book has the authority of a ghost . . .

At the hidden heart of the book there is a hole, and the absence is called spirit . . ."[5]

Six years after *Bible*, the American artist Robert Gober, whose work Dorothy Cross greatly admires, created a monument to the Virgin by piercing a popular statue of her with a huge sewer pipe, and standing her above a running drain in which men's and children's bodies and other elements lay in

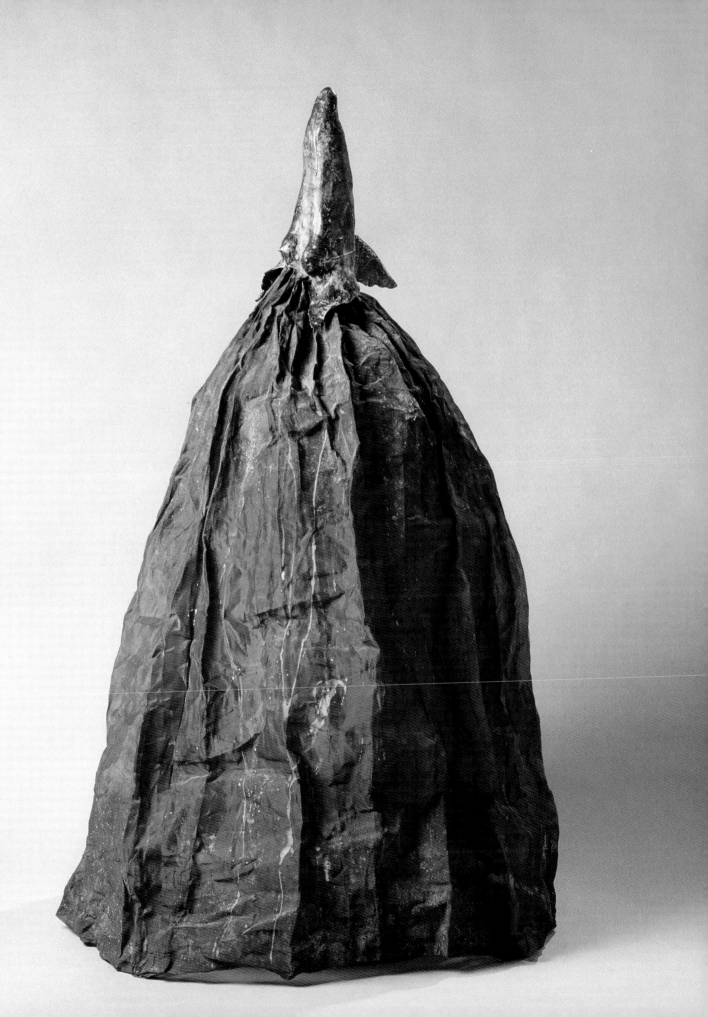

Konrad Gesner,
"Su," a fierce animal hunted
for its skin in Patagonia,
1551–1558

to the disappearing past. Cross now shows courage in entering territories of loss and separation, just as before she boldly confronted sexuality. She says: "We all think of 'enlightenment' and this is the opposite. It refers to the physical in some sense and I see it as something incredibly optimistic. For me the notion of endarkenment is like going back into the subconscious".

This summer, Dorothy Cross will be collaborating with Fiona Shaw on a project for Cork as Cultural Capital of Europe, and questions of inheritance, discontinuity, absence and presence, belonging and parting will return. Together they are devising a complex response to their shared upbringing, as daughters from professional families in the elegant Montenotte area of the city (Dorothy Cross was brought up in Montenotte House), and they have chosen the officers' former quarters in Bleak House on Spike Island, the prison island in Cork Harbour, as the site of a multi-media installation cum performance piece. Dorothy Cross said of it: "My work is often about breaking a line of inheritance, cutting the cords. But what is terrifying is a repetition that's not transformative, an act of return that leaves everything the same".

"Residue" is a key word of value in the artist's vocabulary. She has always shown tenderness towards remnants, leavings, and detritus, and her imagination returns again and again to leavings, traces, artifacts, ordinary articles packed with memories and dreams. "All of modern life prevents us considering our own mortality" she protests. Increasingly she has made the transience of matter—ours and other creatures'—her chief inspiration.

One kind of residue, the relic, establishes contact with someone lost but cherished by synecdoche, through a body fragment; it transforms a complex of attachments into a material thing, by contrast with a souvenir, which reproduces in small scale a place or a friendship that once gave pleasure. Relics are never nostalgic; they are rather active and magical in their retentive function, whereas souvenirs let go of reality without much grief and replace it with memory. Working with skeletons, sloughed skins, seabirds' legs and feet, Cross has infused mortal materials with new energy in works of great aesthetic absorption in the natural beauty of forms. They often also convey a sense of the continuity of life with death: *Untitled (Skull)* (1995) curls an X-ray of a foetus into the brain cavity of a

skull, where it fits exactly: futurity cradled in the symbol of extinction. She says: "You inherit your own mortality. It's your first thing, the origin of creativity". When she turns to the dead past, her work reactivates its shades and its corpses through the magic action of relics. She establishes lines to the past, through buildings and objects and achievements that have been abandoned (the Dublin Power House), or decommissioned (*Ghostship*). She also remembers—or in the coinage of the poet Adrienne Rich, she re-memories—forgotten and overlooked figures. The ambitious mixed media piece, *Come into the Garden Maude*, lovingly explores the achievements of Maude Delap (1866–1953), a highly gifted, amateur naturalist who managed the remarkable scientific feat of breeding jellyfish in bell-jars in the front room of her father's house on Valentia Island.

These gestures of leave-taking involve, as said earlier, retrievals as well as reparation, and in this Cross's concerns recall Seamus Heaney's. In a poem like *Out of the Bag*, the poet remembers his mother giving birth at home to one sibling after another through the metonymy of their family doctor's bag:

. . . its lined insides
(The colour of a spaniel's inside lug)
Were empty for all to see, the trap-sprung mouth
Unsnibbed and gaping wide . . .

But Dorothy Cross's revivification of people and artefacts and their value has been accompanied throughout by attention to another category of transitory phenomena: the natural world. Just as her erotics lead to images of the creaturely, private parts, her naturalist's curiosity has forged a new sensuality about mirabilia, natural wonders. She has undertaken a whole cycle of metamorphoses in which aesthetics and ethics fuse in new combinations to transvalue another population of vile bodies. With Aristotle, Dorothy Cross knows, "though a

thing itself is disagreeable to look at, we enjoy contemplating the most accurate representations of it— for instance, figures of the most despicable animals, or of human corpses . . . "[7] Dorothy Cross's oeuvre boldly grasps this hierarchy that relegates some natural states, and she then shakes it into a different shape. For *Lover Snakes* (1995), for example, she was dissecting the animals and was surprised: "I never imagined a snake to have a heart". She transfigured the reptiles by encasing their hearts in silver reliquary cases, and binding them through their intertwined forms.

Metamorphic art can reconfigure the *informe*: an inchoate or shapeless thing, hitherto scandalously "formless", can cast off its stigma to project a new concept of form itself. In some artists' work, the stratagem involves empathy with the monster and the work inspires in the beholder a new perception of its condition. This approach can be political, feminist, and anti-imperialist, as it transforms those formerly despised and rejected lowlife forms—insects, corpses, abject functions, processes, shapes and creatures. There is an allegorical tendency to this, but in an artist's hands, it can avoid the ponderous didacticism of allegory.

Medusae (2003), an ambitious multi-limbed work of research, film and mixed media artefacts, was undertaken in collaboration with her brother Tom Cross, a zoologist, and it explores one of the most despised species in the universe, as well as one of the most ancient and least understood: jellyfish were on this earth 550 million years ago, 500 million years before homo sapiens. Dorothy Cross finds jellyfish "overwhelmingly beautiful" but they are, she admits, "terribly alien" with their viscous, trailing, slimy shapelessness, their occasionally fatal sting, their seemingly monstrous lack of brain or faculties or face. *Smogairle Roin* is the Irish word for a jellyfish and it means "spit of the seal".

Jellyfish were given their name, "medusae", by Linnaeus, after one of the three Gorgons, who was

afflicted with snakes for hair and given the baneful power of turning to stone anyone who looked at her. In the Renaissance, Medusa's severed head symbolised the defeat of unruly, discordant rebellion: political unrest taking the form of a female monster. Grand Duke Cosimo de' Medici commissioned Benvenuto Cellini to make the sculpture of the hero Perseus trampling her mangled body while holding up her head as a trophy. Caravaggio's Medusa also revels in violence and gore, showing the blood splashing up from the victim's neck as she screams in agony at the very moment of death; this terrifying image is painted on a shield, in order to act as a defensive emblem, like the demonic guardian of a threshold, and repel anyone who approaches the warrior. But the Medusa's repulsiveness has above all strongly sexual associations, and so belongs among those symbolic female bodies Dorothy Cross has enfolded in her symbolic repertory. When Linnaeus named the jellyfish after the Gorgon, he led the way towards Freud's celebrated castration theory, when he identified the head of the Medusa with the sight of the mother's genitals and pubic hair, and its petrifying effect on a boy. Howev-

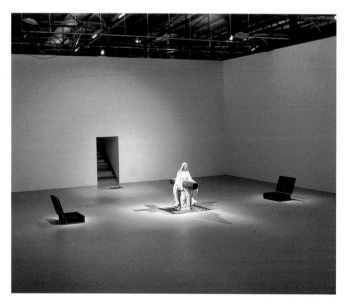

er far-fetched this may seem, the Linnaeus-Freudian association gives an insight into the terror invoked by jellyfish. Some phenomena—tentacular, buggy, creepy-crawly, primordial things such as squid and spiders and crabs and jellyfish—act as *foyers de songe* (dream hearths) and incubate fantasies.

Tom and Dorothy Cross travelled widely to make *Medusae*: they are both excellent swimmers (Tom coached Dorothy when she swam in the Ireland team), so together they were able to experiment at close quarters with their subjects. Tom focussed on *Chironex fleckeri*, the deadliest jellyfish of all, responsible for more deaths in Australia than sharks or crocodiles, and analysed the jet propulsion that powers their rapid movement. Dorothy made the video *Jellyfish Lake*, a dream-like, lyrical piece which shows her drifting, naked and mermaid-like, through galactic shoals of gently pulsing, frilled *Aurelia aurita* and *Mastigias* jellyfish in their unique lagoon habitat in Palau, Micronesia. Swimming so gracefully through their glinting, winking bells and fronds, she seems to cross the boundary of species and to have become a sea creature herself. At the same time, she brings about a transformation of the beholder's sensibility: the flotilla of jellyfish still belongs to the category of disturbing things, but she has unsettled our response and changed the story.

Medusae tackles a phenomenon that by analogy with slime and deliquescence usually provokes abhorrence, and reconfigures "the logic of our imaginary" about these animals, about pleasure and disgust.[8] Dorothy Cross is insisting in this work on her own creatureliness, and on the creatureliness of the human; she is refusing to shudder at any living thing; she is recovering an aesthetic of wonder before the assumed vile body of the jellyfish. *Medusae* refashions and transvalues an animal body and its processes, as it journeys through the cycle from spawning to decay. There is not a little identification when she says, speaking of jellyfish: "It's a defiant animal".

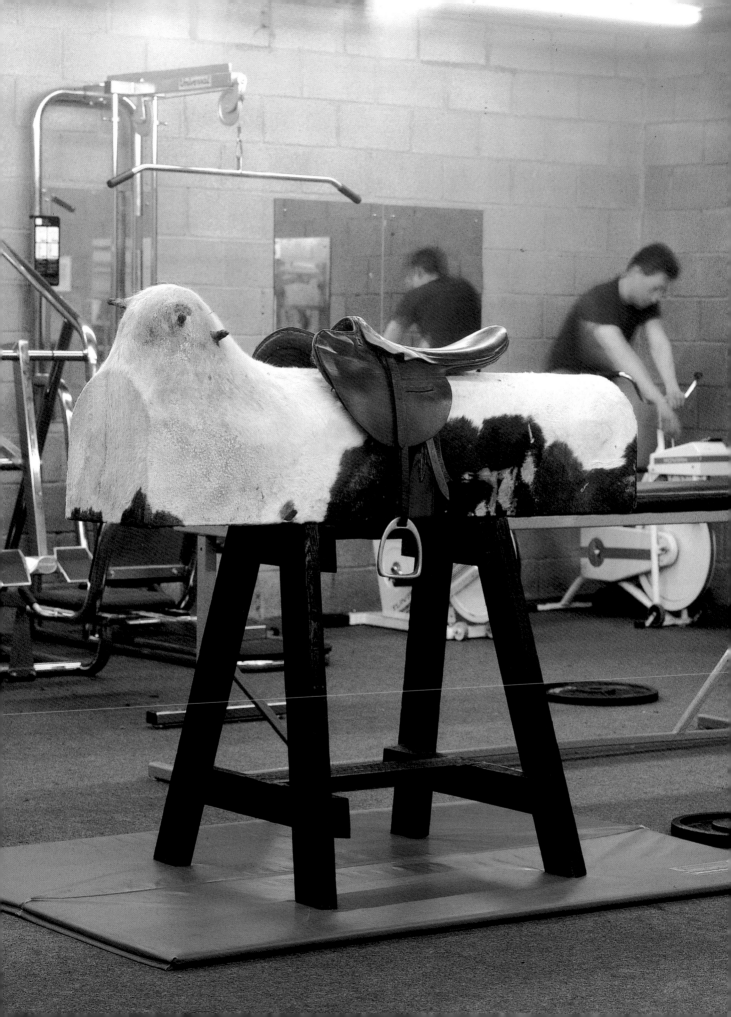

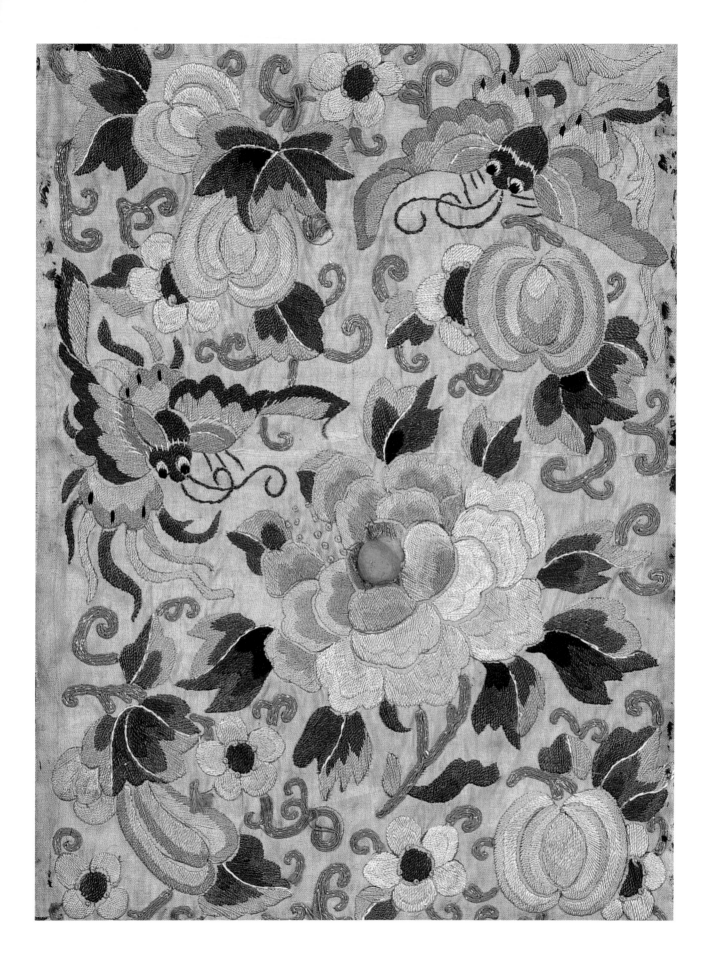

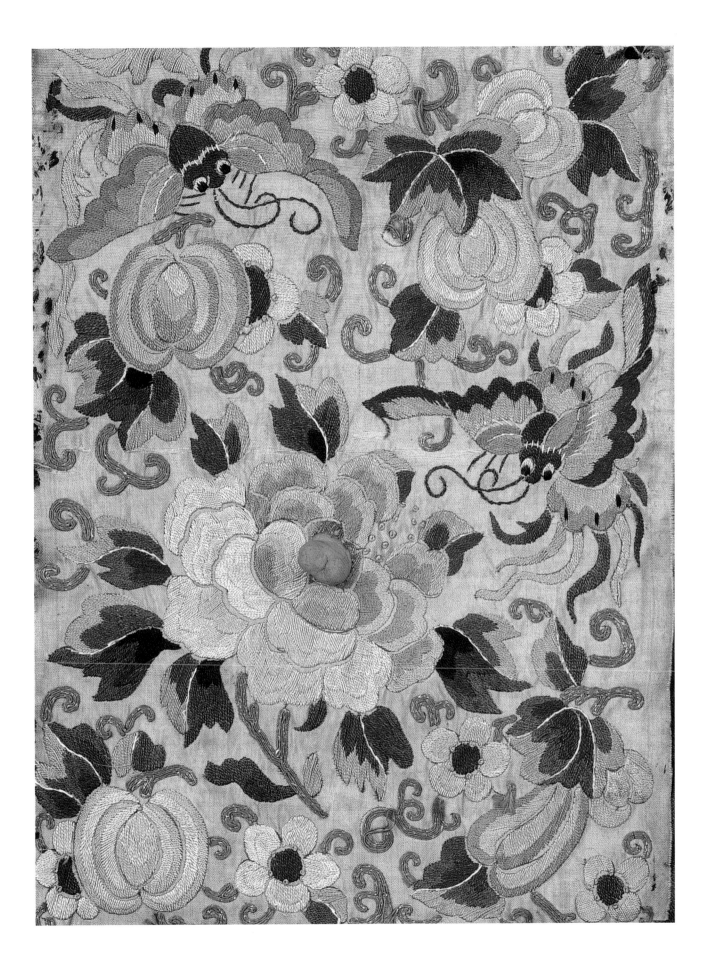

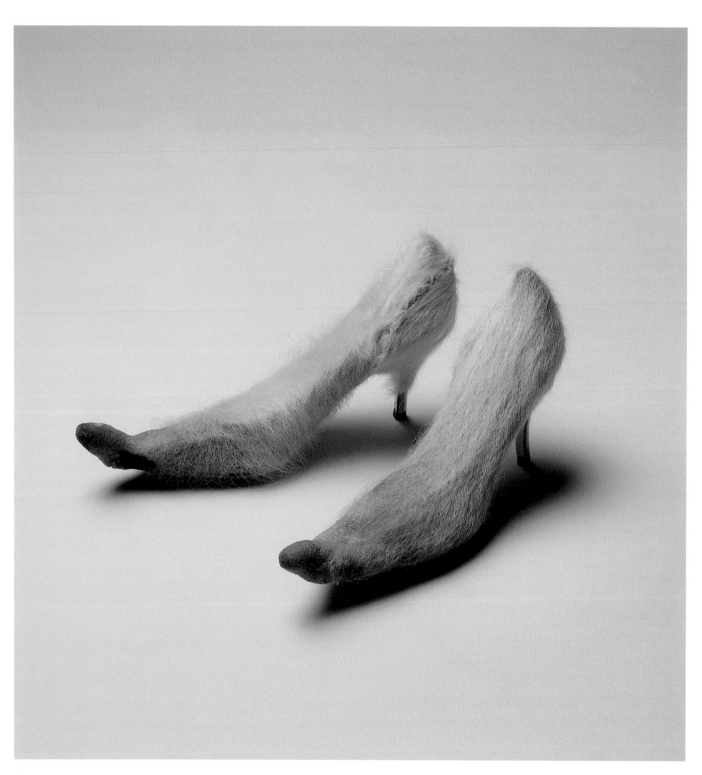

In another yet more profound way, the communion of medusae and artist strikes at conventional aesthetics, especially sculptural. For jellyfish are loose, fluid invertebrates. However, repugnantly fleshy and slimy as they might strike us, they are paradoxically almost disincarnate: 98% water, only 2% animal. They have no being outside their element, and so exist in harmony with the sea, almost emanations of its currents and eddies. Consubstantial with water, they embody contingency and interdependence, announcing the reciprocity of our relations as living creatures with the stuff in which we survive. The fringes of the jellyfish cannot be reconstructed outside the sea; the animals are so insubstantial that a shadow on the bottom is often the only sign of their presence. Such lightness makes them a sculptor's paradox: sculpture here has done with the column and the skeleton, the scaffold and the rock. They belong in the symbolic category of the wet, slippery, inchoate feminine, primordial and chaotic, and in this set up an order of beauty at variance with classical orders of architecture, pillar, statue, monument and their embodiment of masculine authority. But Dorothy Cross has discovered in them beauty and decorum: she laid out jellyfish she had found in the sea near her home on hand-trimmed and embroidered white handkerchiefs such as a Victorian lady like Maude Delap would have kept in lavender scented presses; the creatures, drying out, left the shadow of their form in a sepia residue on the cloth; this is nature's own drawing, *acheiropoieton* or "made without hands" like a miraculous story of the holy shroud.

In 1999 Dorothy Cross staged an elaborate performance piece, *Chiasm*. Comparable to *Stabat Mater* in its mingling of film, opera, and a unique setting, *Chiasm* was staged in disued handball alleys. She flooded the spaces with projections of the sea surging and filling an ancient, rectangular blowhole nearby. The tenor sang in one alley, the soprano in the other, with the wall between them,

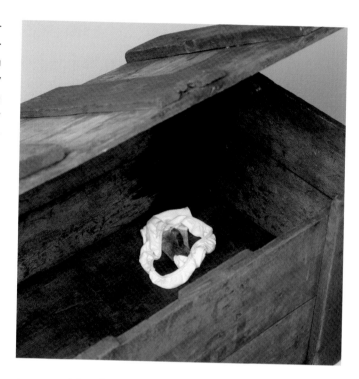

impassable; their yearning encapsulated a profound sense of severance. As the title of the piece conveys, the artist was dramatising the gap that cannot be closed between self and other, self and world, even in the midst of belonging, of being here in the country, in the landscape and the history.

The word "chiasm" means a certain type of cross (on the diagonal), and puns on her own surname arise quite frequently—and all unconsciously—throughout Dorothy Cross's work. At a deep figural level, her work often places the viewer in a quandary, just as an enigmatic crux in a piece of writing resonates powerfully when it cannot be solved or fully understood. She crosses pleasure with tension, attraction and repulsion; invites passionate identification with the artefacts she makes, and at the same time often repudiates them. Her art has evolved metaphors that upset the normal hierarchy of things and it stirs cross-currents of meaning; in this way she crosses, in the sense of contradicts, expectations. She also deliberately cancels—

crosses out—conventional signs about what is valuable, beautiful and sacred. She crosses one element with another, creating a kind of amulet to ward off danger or anxiety. It is interesting that in some children's games, the cry "Cruces", accompanied by a gesture of crossed fingers, is the magic word used to beg for quarter from a pursuer.[9]

The Virgin Mary and her son returned to hold the centre of Dorothy Cross's imagination for her most ambitious recent work, the *Stabat Mater* (an enraptured meditation on another kind of cross). For the performance of Pergolesi's great sequence, Dorothy Cross raised a vast screen in the mouth of the cave, and filled it with the projection of an open mouth. The passionate anguish of the music resonated off the slate ramparts of the quarry that were sluicing with water: the staging turned the now-neglected Marian grotto into a Sibylline cave, a prophetic mouth, a womb crying out, as when Aeneas heard the Sibyl overcome by the god of prophecy Apollo, and the whole mountainside echoing with her cries.

But the Marian grotto doubles as a working slate mine, and the artist included as part of the staging a video of the workers at their heavy machinery, sawing and parting the fine-grained, deep sable strata—Valentia slate ranks as the highest quality roofing material in the world. The two functions of the cave—the shrine and the quarry—co-exist uneasily, the industrial use trespassing on the sacred site, defacing its aura, as if the holiness of holy ground came and went like a light bulb turning on and off. The eloquence of Cross's production in this setting rose from her forcing the two roles together, insisting on the hallowed character of the quarry workers and of their labour by turning them into the celebrants of the music. In oilskins and boots, with the wind blowing the sheeting rain into their faces, the singers emerged out of the depths of the huge cave as if taking a break in their shift, and began singing out as if the death of Christ was something they were seeing then and there. They became messengers of the redemptive spectacle the words evoke, and the audience became pilgrims, huddled together at the communion rails, which are painted sky-blue in the Virgin's honour. As the rain spread and twisted under the arc lamps, falling in shining veils against the blackness of the cave's depths, on the performers and on their instruments, the elements seemed to be caught up in the drama of Golgotha:

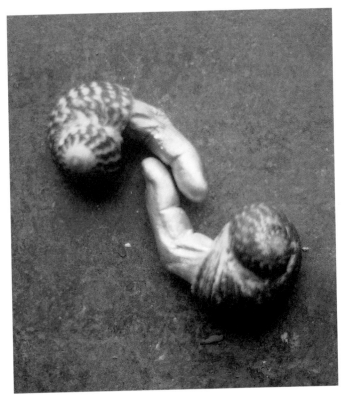

> *Quis est homo qui non fleret*
> *Matrem Christi si videret*
> *In tanto supplicio?*
> (Who could there be who would not weep to see the mother of Christ in such torment?)

Everything was caught up in the streaming music, the weeping elements—we were wrung in sympathy.

The spirit of the piece corresponds faithfully to the ways of praying that the Franciscans introduced in the twelfth century, when the order invented the Crib, placing a baby doll in the manger on Christmas Day so that the faithful could play-act the coming of the Christ in their ordinary lives, as if it were happening for them, then and there. The highly charged dramatic verses of the *Stabat Mater*, written by a Franciscan friar in the thirteenth century, move between the agony of Mary at her son's death, the voices of the attending crowd, and the testimony of an eye witness describing the Passion. But at mid-point, the subject's angle of view shifts again, and the singer takes up the lament in the first person, and begs to enter Christ's passion and suffer his torture as well as Mary's. The soaring pathos of Pergolesi's music accentuates these pleas, and we in the audience are made to leap with the singer across time and space, with history abolished and the past turned into the present.

Rituals such as the family rosary played no part in Dorothy Cross's upbringing in Cork, but she of course knows firsthand the heightened emotions that surround allegiance to the Blessed Mother and separation from her. The dilemma is recognisable: her symbols draw powerfully on the myth while fiercely rising up against all of its miserable, subjugated, docile conception of men and women, laid out in death "their dough-white hands/shackled in rosary beads".[10]

Dorothy Cross's *Stabat Mater* exemplified this duality. After the Pergolesi piece closed, the colossal screen was cranked forward and a film of the quarry workers, accompanied by the clamour of their machinery and close-ups of their action, filled the vast space under the hood of the cave. The footage of an ordinary day's work in the shrine also dims its aura, restores it to our level. The artist was staging a deposition from the cross in more ways than one, for she lowered the numinous intensity of the Pergolesi to ground us in this time and place, and return our thoughts to the crucial matter of life, here and now.

1. Eamon Duffy remembers this ritual from his childhood, in *Madonnas that Maim? Christian Maturity and the Cult of the Virgin* (Glasgow: Blackfriars Publications, Aquinas Lecture Glasgow, January 1999), p.1.
2. Ovid, *Metamorphoses*, Book IV, where he describes the scene of Salmacis' ardour and its effects with some distaste—the alchemical tradition by contrast exalted this process.
3. With thanks to John McBratney for this information, from a conversation, August 2004.
4. Rosalind Krauss, *Antivision*, October 36 (Spring, 1986), pp. 147–154 is the classic essay on this aesthetic turn. See also Simon Taylor, "The Phobic Object: Abjection in Contemporary Art" in *Abject Art: Repulsion and Desire in American Art*, catalogue, Whitney Museum, New York, 23 June – 29 August 1993, pp. 59–83.
5. James Conway, *Even: Dorothy Cross*, catalogue of show at Arnolfini, Bristol, 24 February – 14 April 1996, p. 22.
6. Roy Foster, *Irish Story: Telling Tales and Making It Up in Ireland* (London: 2001). See also Fintan Cullen and R.F. Foster, *Conquering England: Ireland in Victorian London*, catalogue of exhibition at the National Portrait Gallery, London, 8 March – 19 June 2005.
7. Aristotle, *The Poetics*.
8. Roger Caillois uses this phrase in his study of the octopus, an animal related to the jellyfish in mythopoeic qualities. See *La Pieuvre, Essai sur la logique de l'imaginaire* (Paris: 1973).
9. Iona and Peter Opie, *The Lore and Language of Schoolchildren* [1959] (New York: 2002), p. 150.
10. Seamus Heaney, *Opened Ground: Poems 1966–1996* (London: 1998), p 96.

Udder 1990–1994

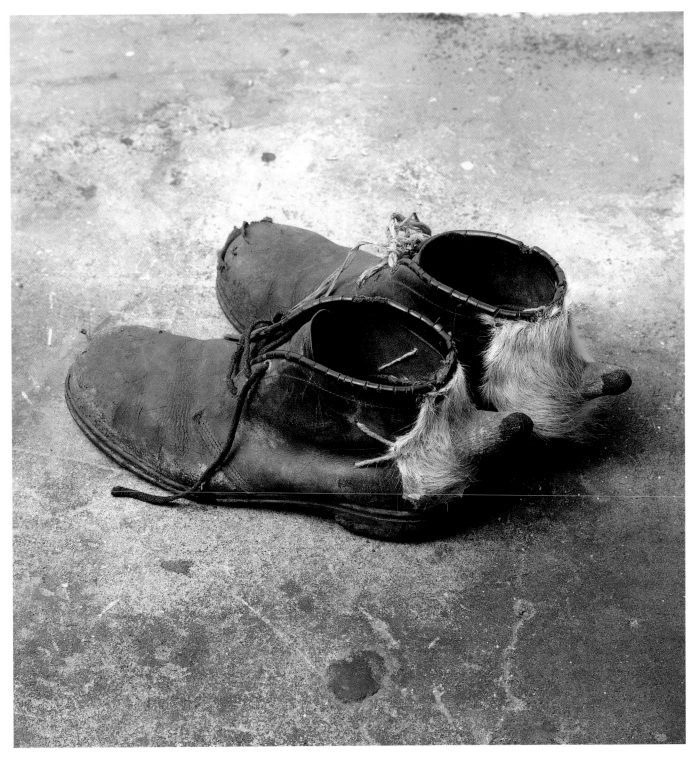

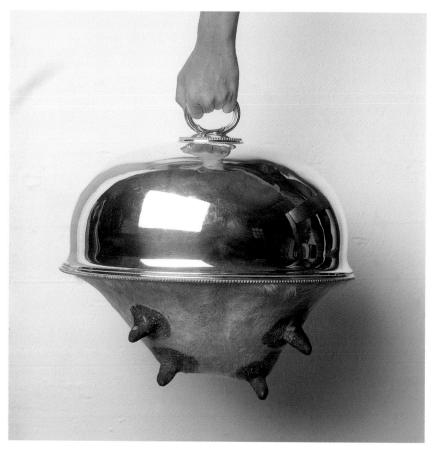

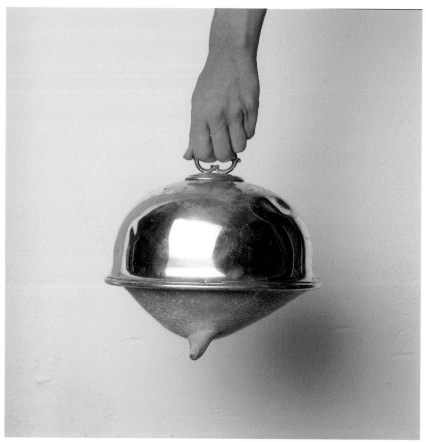

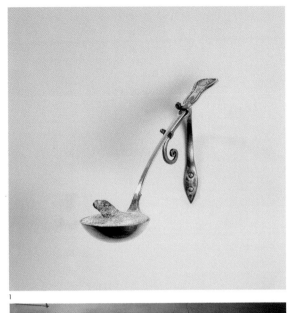

1

2

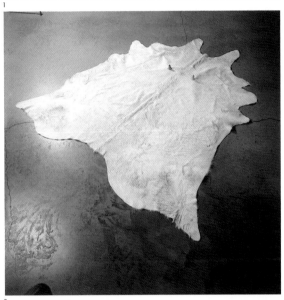

3

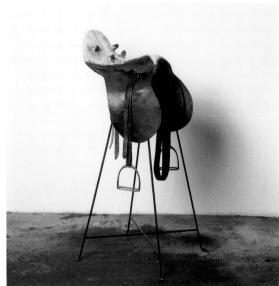

4

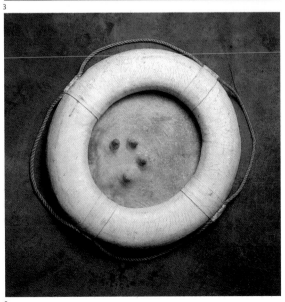

5

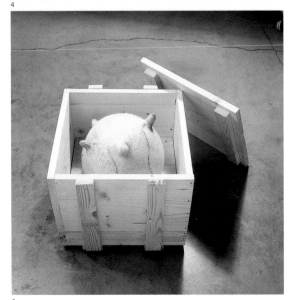

6

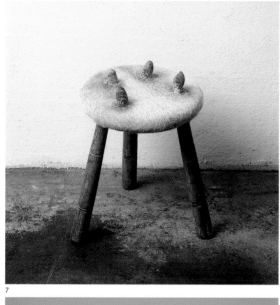

7

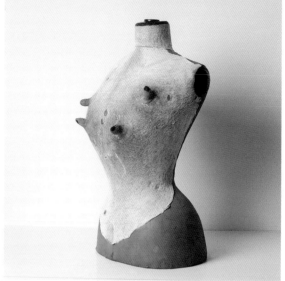

8

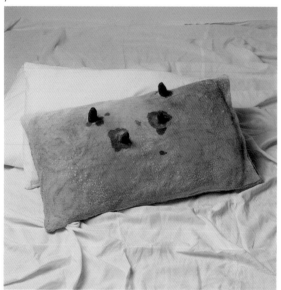

9

10

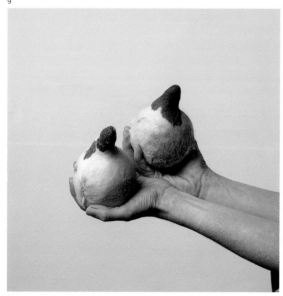

11

12

13

14

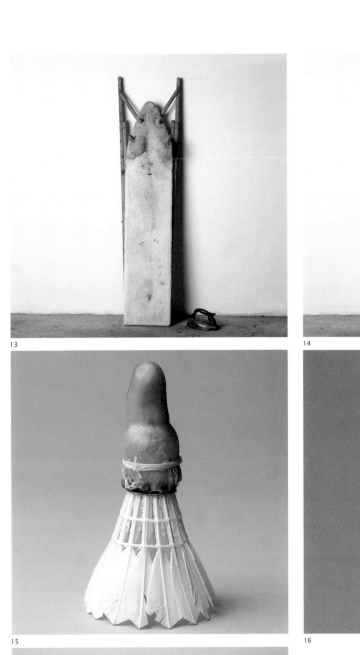

15

16

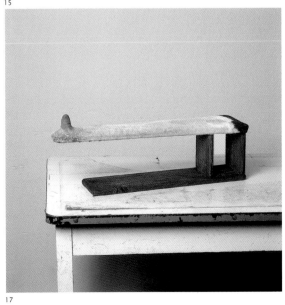

17

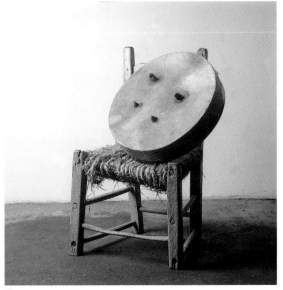

18

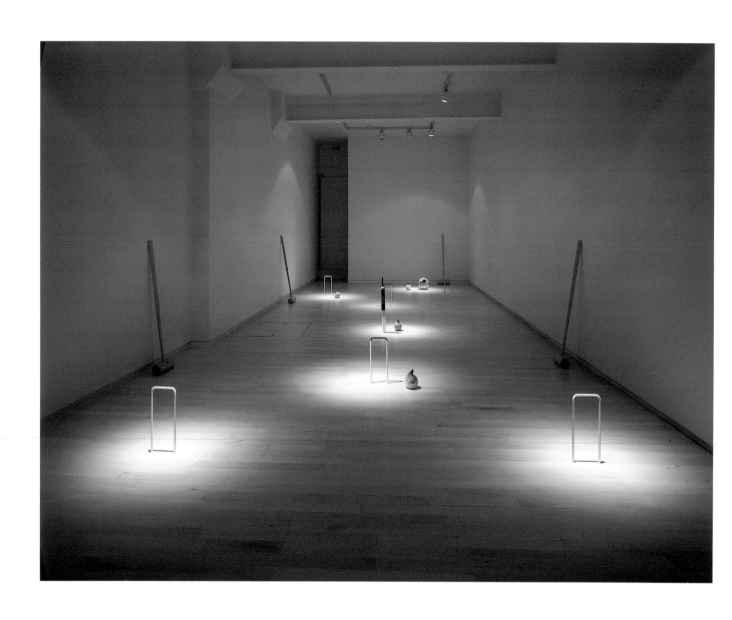

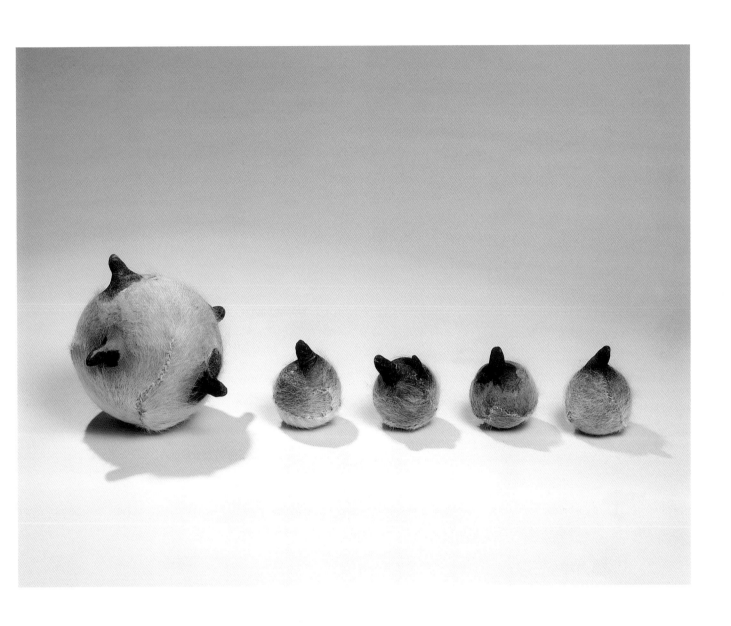

Stabat Mater

Dorothy Cross

In 2001 I visited Valentia Island to research the life of Maude Delap (1866–1953), an amateur naturalist who succeeded in breeding jellyfish in bell-jars in her father's house in 1902. The island of Valentia is located off the southwest coast of Ireland. I followed signs saying "Grotto" and found a vast arena. The Grotto contains statues of the Virgin Mary and Saint Bernadette located above a gaping hole of sliced rock leading into the mountainside. It is a place of overlapping elements: an excavation into the earth, an amphitheatre, an industrial slate quarry and a shrine. My immediate desire was to hear beautiful voices there. I spoke to the then director of Opera theatre company, James Conway, with the idea of Monteverdi's *Orfeo*. He suggested the Pergolesi *Stabat Mater*.

The *Stabat Mater* is about striving for passion: remembering and forgetting pain and pleasure. Locating such beautiful music in the damp, dripping cave where workers cut and slice rock all day was a perfect collision. The music was written nearly 300 years ago by a man who died at the age of twenty-six. The location is a place with a history of cutting slate for the roof of the Paris Opera House and where crowds attended pilgrimage masses in the last century.

The *Stabat Mater* was performed by a soprano, a countertenor and nine baroque players. They emerged from the back of the cave dressed in worn and dirty workmen's clothes as if stopping from a shift. They began to perform in an expressionless way like the repetition of a learned prayer. As the performance progressed it was as if they recognised the passion of their words. They finished and returned to the quarry. A rig was built emerging from the depths of the cave carrying a large screen towards the front. During the performance a still mouth hung open behind them. When they left, the video began. The mouth moved and industrial sound blasted the space. Images flashed from open mouth to slicing machine, from dripping cliff face to workers' repetitive gestures, the singers walking into the depths of the vast Wagnerian cave to the statues of saints above their heads.

Weather intervened on the three nights of the performance. The prevailing winds, normally southwest, turned directly north and blew straight into the cave. Sheets of horizontal rain soaked the singers, drops pouring down their faces like tears. The players retreated further and further back into dryness to protect their instruments. Contrary to disaster the elements added a power that could not have been faked. The beauty of the *Stabat Mater* enhanced by nature.

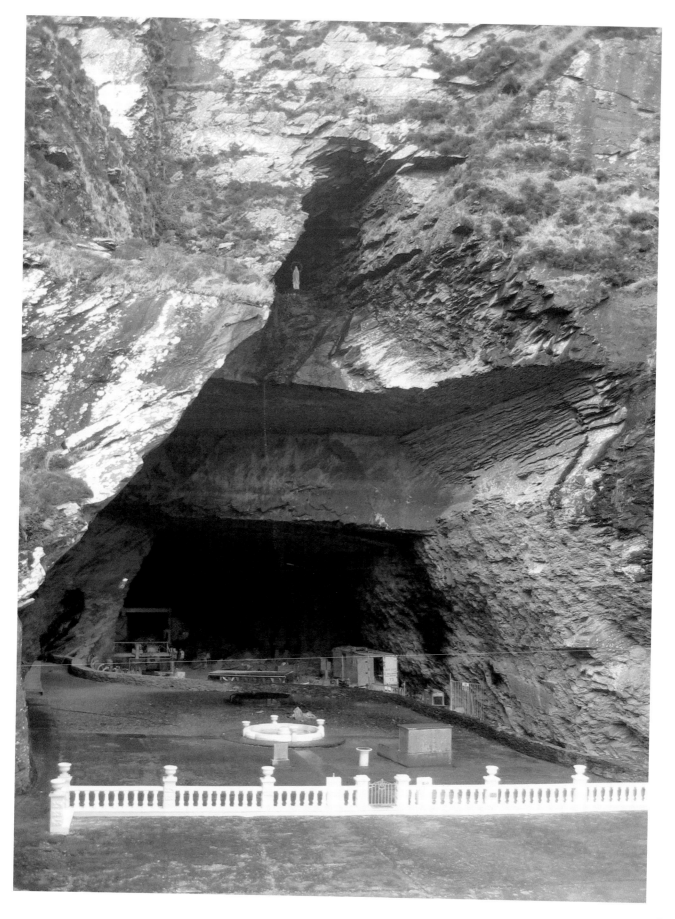

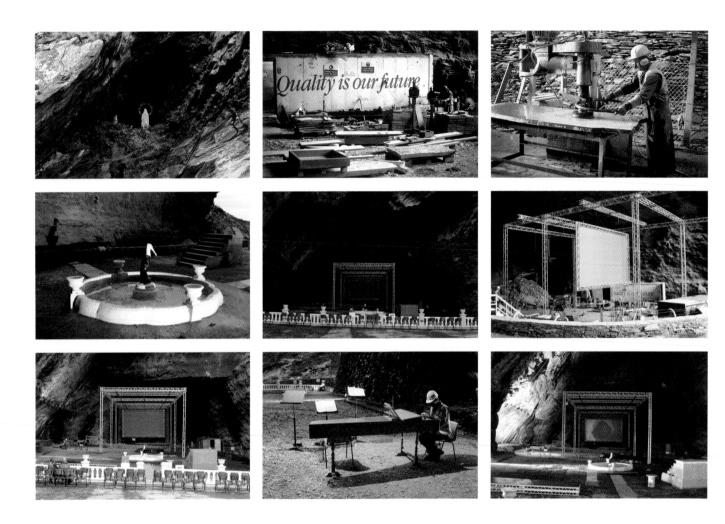

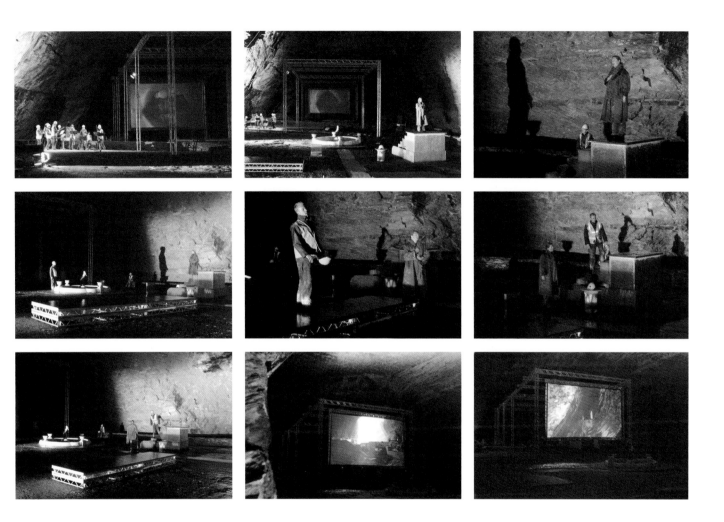

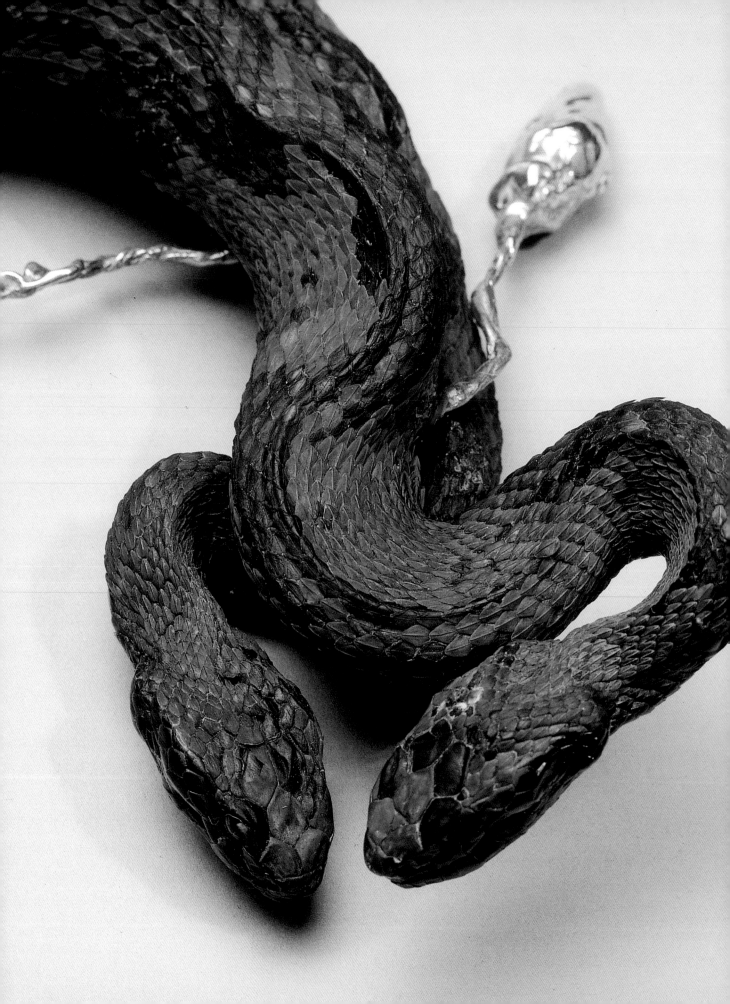

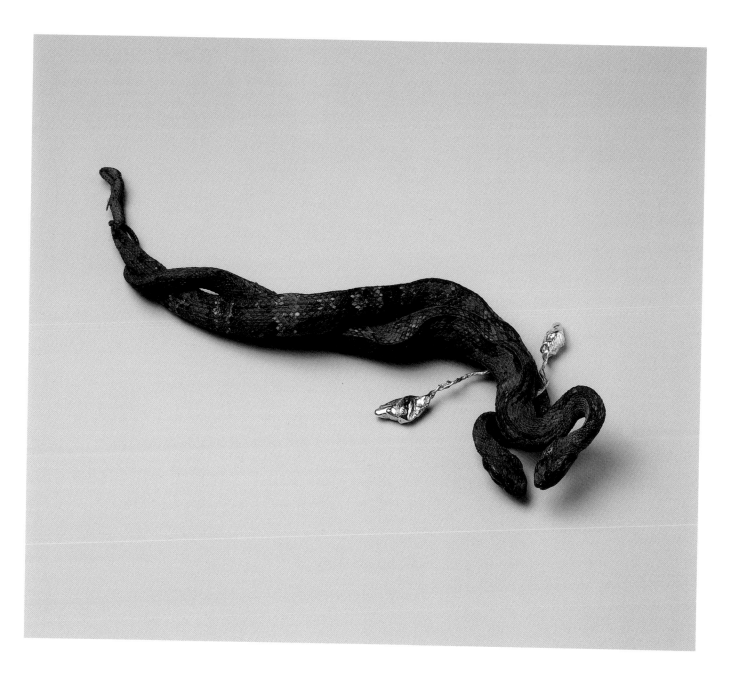

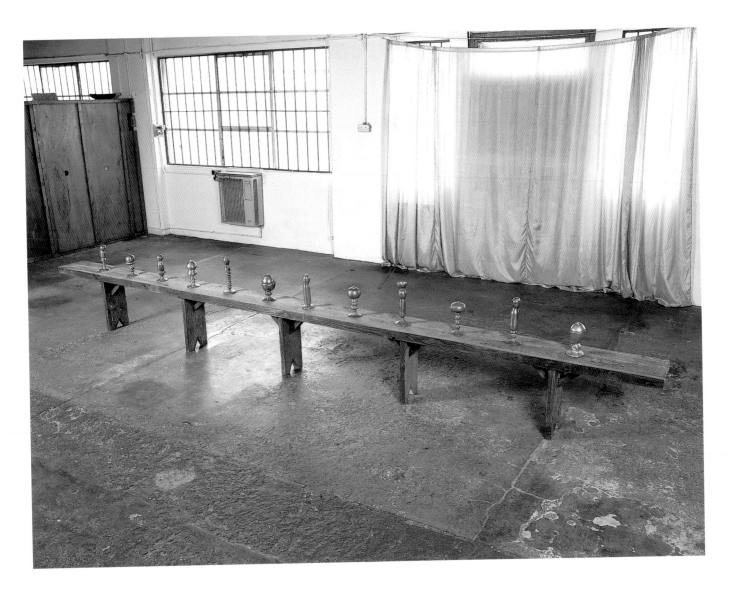

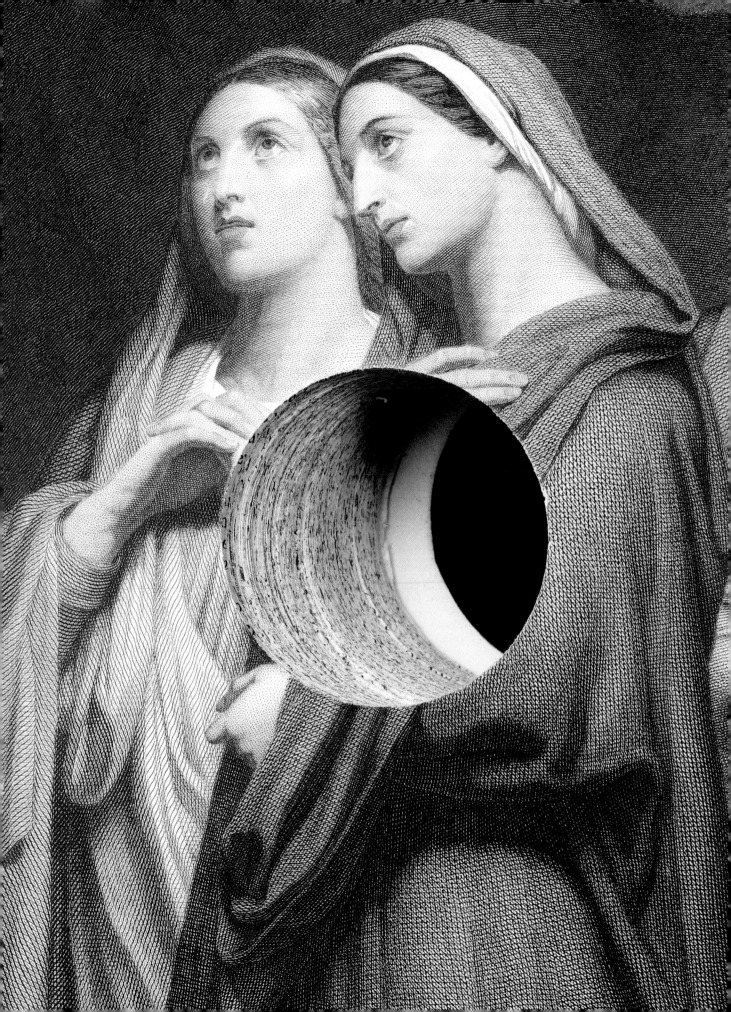

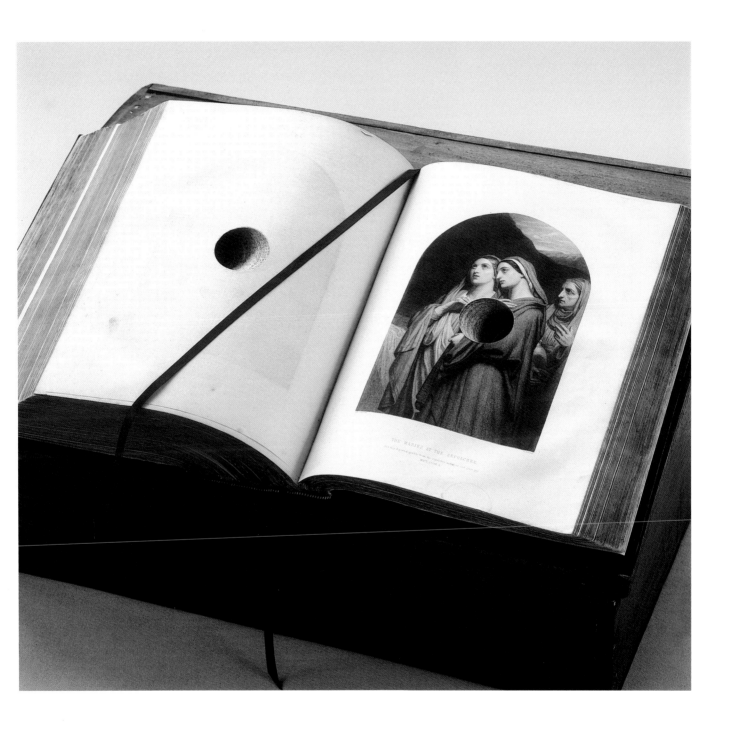

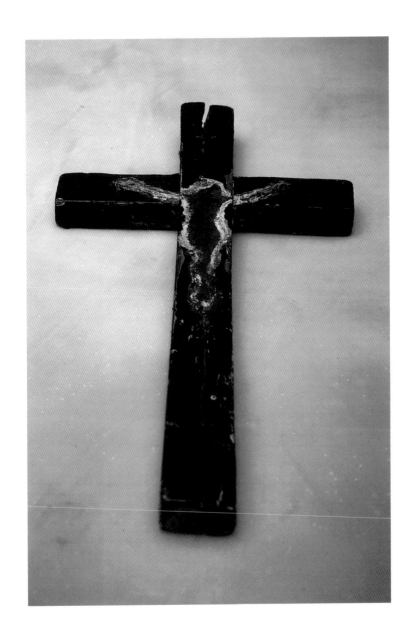

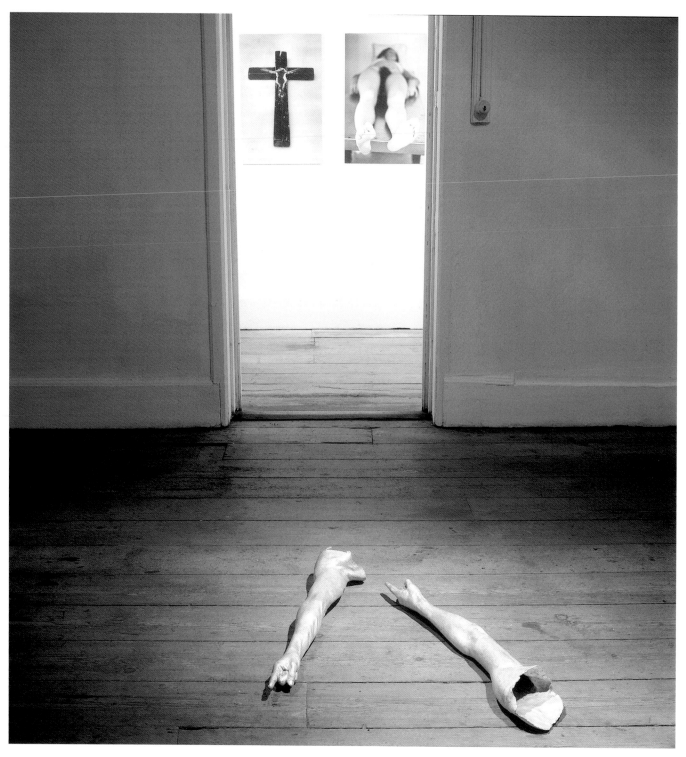

Finger print 2002

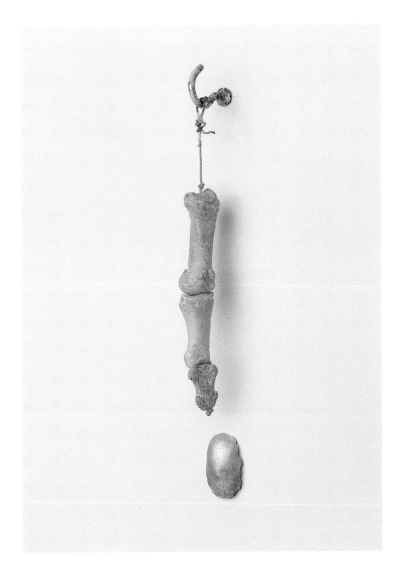

**Close your eyes and open
your mouth and see what God
will give you** 1995–1996

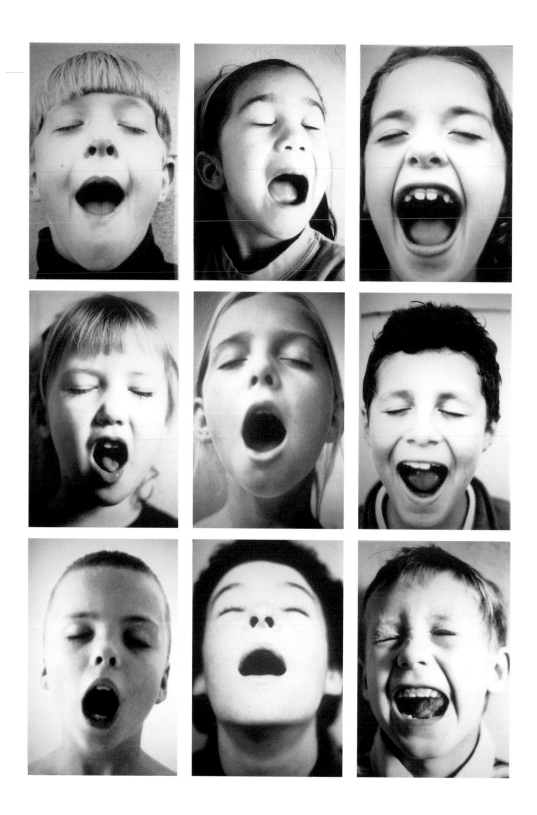

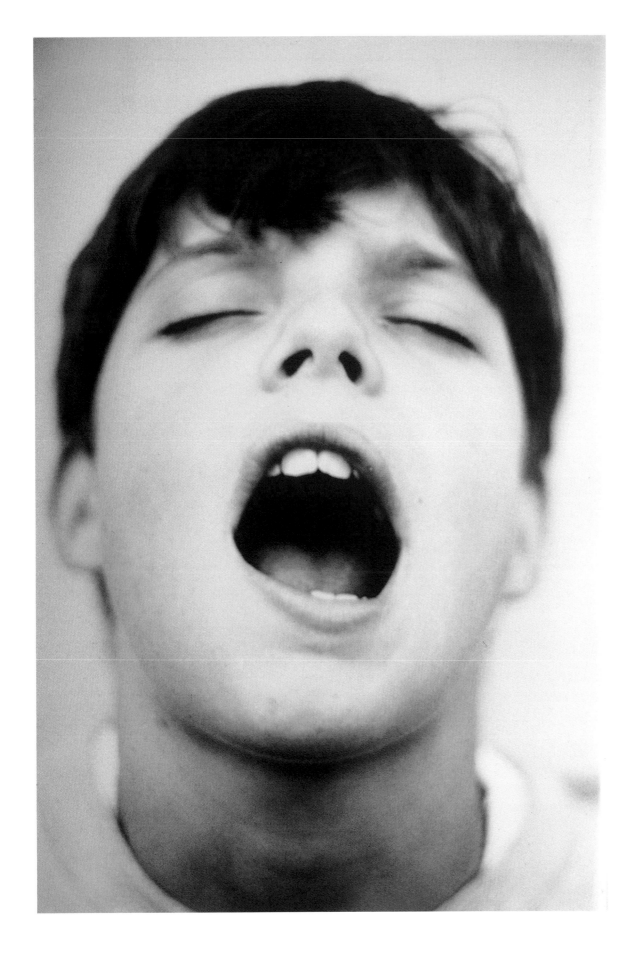

Corrosive Vision

Ralph Rugoff

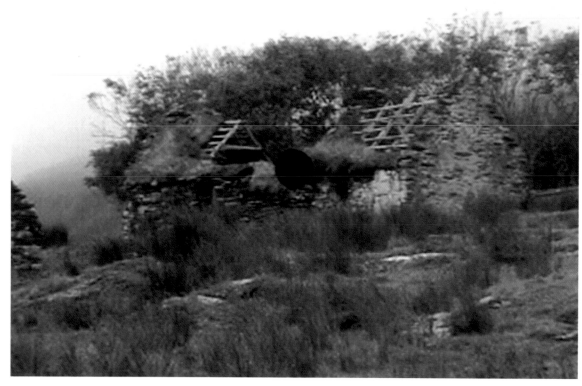

According to a popular truism, artists are in the business of imposing order, giving fixed form to the chaos of existence. Yet most truly interesting art is also corrosive. It is keen to remind us that the rhetorical figures and framing it calls into play are mere devices, formulations of artifice that can never fully contain or conceal the shapeless flux of the phenomenal world. By insistently hinting at its own contingency, this kind of art also prompts us to look askance at the arbitrary nature of all our cultural constructions, including our dearest values and truths—and even those fundamental categories, such as order and chaos, that we routinely deploy to classify and make sense of our experience. In a number of Dorothy Cross's video works from the past decade, we encounter precisely this kind of thoughtfully subversive impulse, this concern with underscoring the precariousness of cultural frameworks and hierarchies that we often assume as givens.

Conceptually driven, these works typically present individual scenarios rather than narrative sequences of causally-related events. Through this singular focus, they force us to pay attention to the different frames that shape our encounters with moving images and the ways we ascribe meaning to them. These works also introduce us to troubling forms—or rather, to forms that trouble our desire to order, delimit and classify our perceptions of the visible world.

With an ironic elegance, Cross conjures that desire in *Teacup* (1996). Shown to scale on a ten-inch monitor, this video depicts images of the proverbial tempest in a rather refined example of the aforementioned piece of china. But this is not just any storm: the grainy black-and-white footage of a small boat battling a roiling sea that Cross has placed in her teacup comes from Robert Flaherty's documentary *Man of Aran* (1934), a deliriously romantic and carefully staged

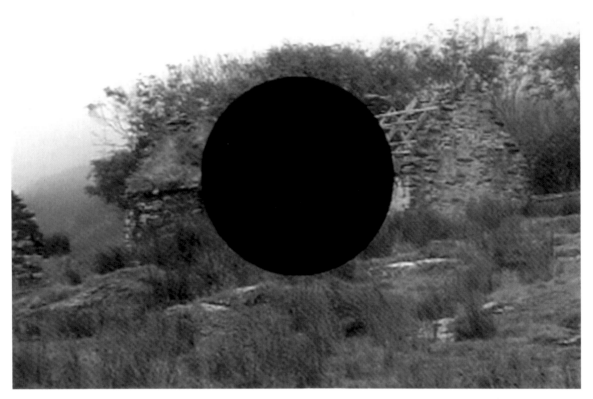

homage to the proud fishermen of Ireland's western isles. In the film sequences that Cross has selected, a lonely fishing boat—the traditional currach—repeatedly appears and then seemingly disappears behind a succession of rolling waves. Continually escaping the camera's gaze, its visibility seems to be in constant jeopardy. From time to time, meanwhile, the camera rapidly pans across the sea to no apparent purpose, as if searching for a furtive subject. Finally, a series of close shots show the currach breaking up on the rocks, consumed by the raging surf.

In presenting this progression from elusiveness to dissolution, Cross's video alludes to the historical disappearance of a way of life that had once been part of Irish culture. At the same time, it also calls our attention to questions of framing. As the currach repeatedly escapes from our field of vision, it arouses and frustrates our desire for an accessible subject,

a central focus—for an image, in other words, that affords us an illusion of control. At the same time, by framing images of nature's chaos within a domestic teacup, Cross humorously evokes the absurdity of attempting to contain the uncontainable. Indeed, the cup's twee appearance conjures the decorousness of all our efforts to neatly frame the disorder around us, to dress up formlessness and shapelessness in disguises that conceal the true character of our perceptual encounters.

With *Teacup*, Cross questions the formal and conceptual frameworks through which we interpret the visible world, while foregrounding our activity of looking. *Eyemaker* (2000) further explores this territory with what initially seems like a straightforward documentation of the making of a glass eye. Beginning with a medium shot depicting a craftsman behind a worktable laden with precision-tooled instruments, the

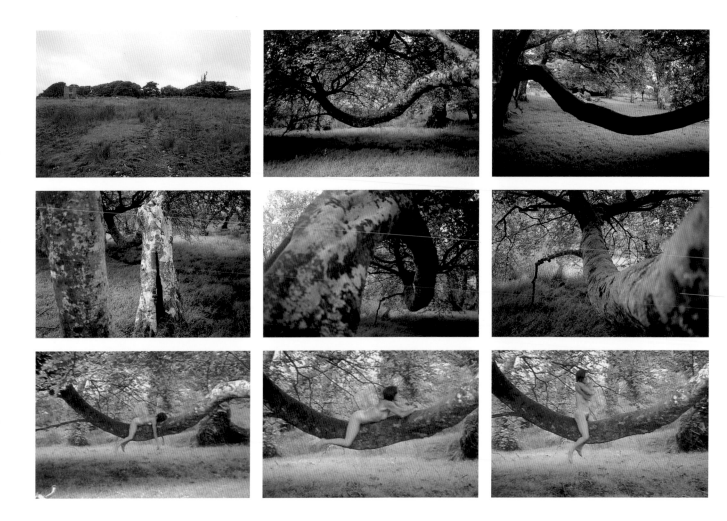

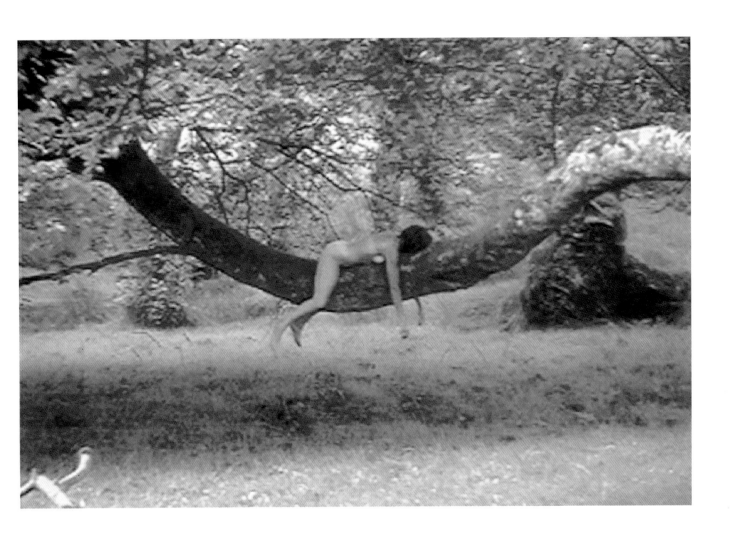

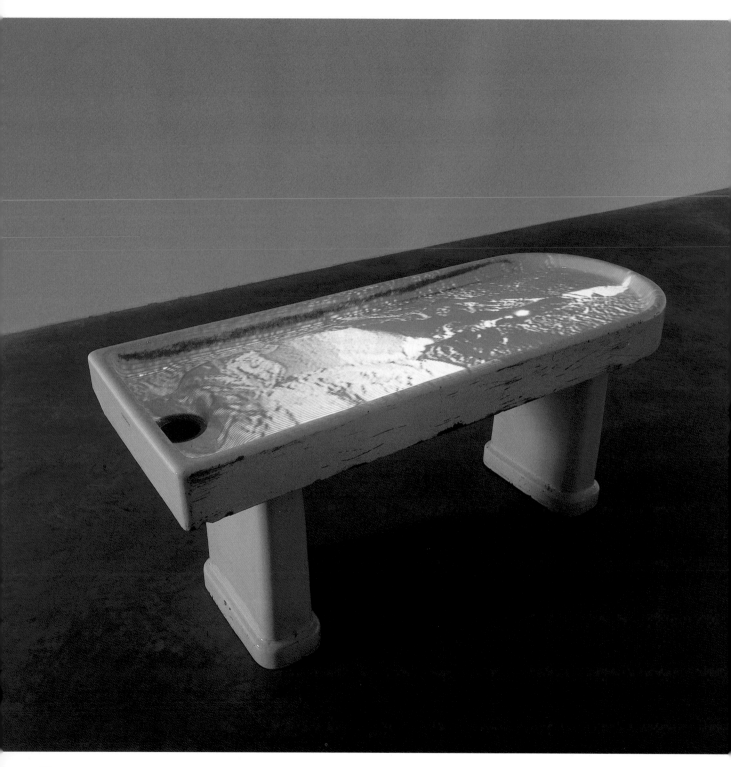

video chronicles the painstaking process of firing and shaping raw matter into a life-like prosthesis. Much of it is shot in extreme close-ups that immerse our vision in intensely visceral sequences during which the "eyemaker" twirls, pokes, scars and stipples his orb of molten material into shape. These chaotic images are at once compelling and disturbing. As the "eye" is being gouged with a metal instrument or as threads of glass are pulled from its surface, the fact that we associate it with a human organ engenders feelings of horror and repulsion as well as fascination.

That underlying note of violence reaches an abrupt climax as the video concludes with the craftsman unexpectedly inflating the glass eye as if it were a balloon and popping it. The screen then goes dark as if we have lost not only the object but also the instrument of our vision. With this sudden act of destruction, Cross underscores that everything we have just seen has been a performance staged for the camera, rather than an innocent documentary depiction of a craftsman at work. In a kind of conceptual double-entendre, Cross's film about the making of a false eye—an artefact designed to deceive our vision—ultimately reminds us that there is nothing natural about images. Instead, artifice and potential treachery are inherent in the field of visual representation, leaving us perpetually vulnerable to misreading (and inaccurately classifying) the surfaces and events we perceive.

In the extreme close-ups in *Eyemaker* that depict the manipulation of molten materials, we confront images that verge on illegibility. The ambiguous appearance of both form and substance undermines our ability to clearly distinguish and categorise what we are seeing. Or perhaps more accurately, what we are seeing defies the conceptual frame that we would impose upon it—a frame, in this case, derived from our pre-existing notion of what an eye looks like.

With *Jellyfish Lake* (2001) Cross elaborates on this play of subversive form—form that deforms our formal categories—in presenting a disorienting underwater pageant featuring thousands of jellyfish and a naked female body. Filmed in a lake in Palau, Micronesia, Cross's video opens with an astonishing image of flux and fluidity: a view of hundreds of small jellyfish bobbing and jiggling in water animated by undulating

rays of light. Androgynous-looking, alien, and formally unstable, the jellyfish is a creature that inspires both awe and revulsion. Devoid of eyes or a face, its appearance seems truly monstrous. Yet Cross pointedly echoes that appearance in her depiction of a female body that provides the central focus of the video's subsequent shots. The underwater camera depicts this naked swimmer (or floater) from her chin and ears to her waist, while her face, presumably above water, remains unseen. Filmed from below, her neck and chin appear to join their reflections in the water's surface, creating an uncannily doubled, and faceless, anatomy with flesh rendered strangely gelatinous by the undersea light. In other shots, Cross's camera closely frames her luxurious tresses of hair—which are also doubled in the lake's reflective surface—as they rise and fall, fanning out in the water with a weird grace rivalling that of the jellyfish that surround and nestle against her body.

In de-familiarising our conventional image of a human form and visually linking it to the indeterminate and oscillating anatomies of hundreds of jellyfish, Cross invites us to surrender our usual ways of looking, as well as the various distinctions we draw between the grotesque and the beautiful, between what we find alluring and repellent. *Jellyfish Lake* lays out a vision of a mercurial landscape in which all forms, and the liquid world around them, are continually in motion, eluding our fixed definitions. In the process, Cross's video conjures a vertiginous sense of the contingency of vision, and of our status as subjects on a perceptual playing field in which difference can fluctuate and come undone like shapes in a funhouse mirror.

In *Jellyfish Lake*, Cross formulates a lushly corrosive visual logic that denies that each thing has its proper form, or a true and static character that can be neatly categorised. With *Endarken* (2001) the artist seemingly takes a more straightforwardly nihilistic approach in undoing the transparency and assumed meaning of an iconic subject. The video commences with a nostalgic image: a static shot featuring a ruin of a thatched cottage in an idyllic rural landscape. It is a pictorial cliché that conjures Irish heritage and tradition as well as tourist advertisements designed to appeal to our yearning for authenticity. But after fifteen seconds or

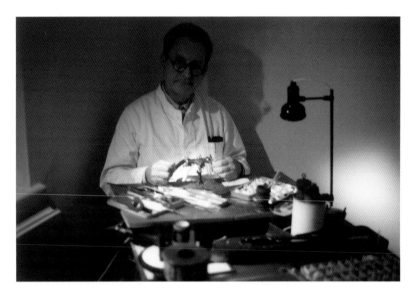

so, this innocent-looking scene is abruptly denatured as a black dot emerges from the centre of the cottage, and gradually expands until it fills the entire frame. Resembling an expanding cartoon inkblot (or the graphic device that used to introduce mid-twentieth century animated short films), the black dot is curiously menacing. Whereas the initial scene wraps our gaze in a comforting nostalgia that suggests the innocence of our looking, Cross's animated addition conjures a censorial act of obliteration. It is an abject blot whose significance stems precisely from the fact that it signifies nothing. Yet in interrupting the photographic clarity of the image and its implicit assertion of a seamless reality, it opens up alternative fields of meaning. As the dot spreads across the image like a traumatic stain, it de-familiarises the homely scene and renders it suspicious. It replaces the harmonious picturesque prospect that we first view—and which solicits from us a detached and passive gaze—with an ambiguous landscape, a site haunted by hidden or absent meanings that we may explore only if we forfeit any pretence of being objective observers.

Endarken also hints at the way that visual clichés function as cultural blind spots, and suggests, paradoxically, that an "enlightened" approach to reading such images may require us to muddy, and so denature, their apparent lucidity. This attitude, in fact, distinguishes all of the videos discussed above: in each,

Cross puts into play a phenomenology of identification and de-identification, recognition and misrecognition, challenging us to see beyond the pat categories and clichés that blind our thinking. As if allergic to definitions of any kind, Cross's work instead invites us to imagine meaning as something impure, protean and potentially amorphous. And most importantly, perhaps, it implicates our act of seeing in the images it presents to us. In one way or another, these videos underscore the porousness of vision, the fact that our seeing is never innocent, but always intimately and inextricably linked with frameworks of cognition and interpretation. Cross's art affords us the pleasure of this expanded experience of perception and in the process offers us a chance to reimagine and refresh our readings of the visible world.

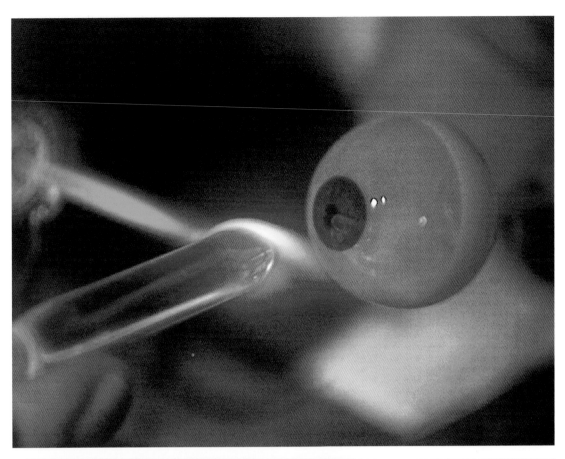

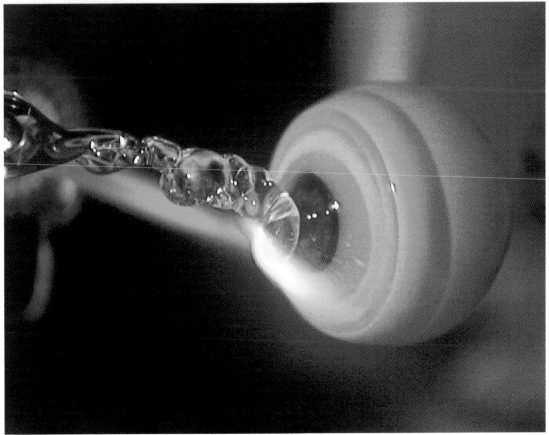

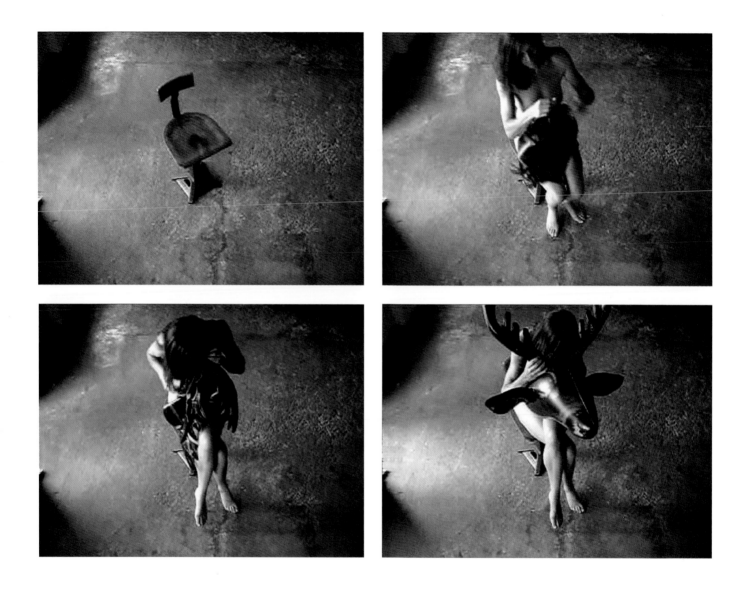

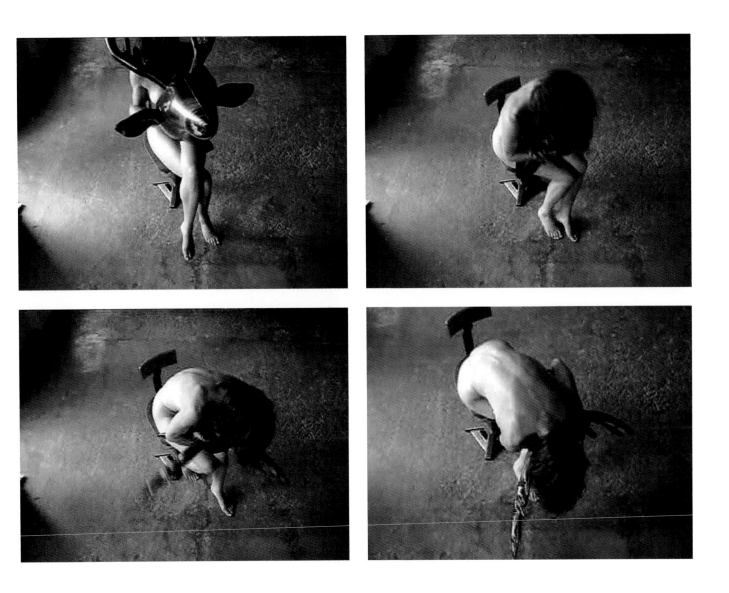

Figure 2001

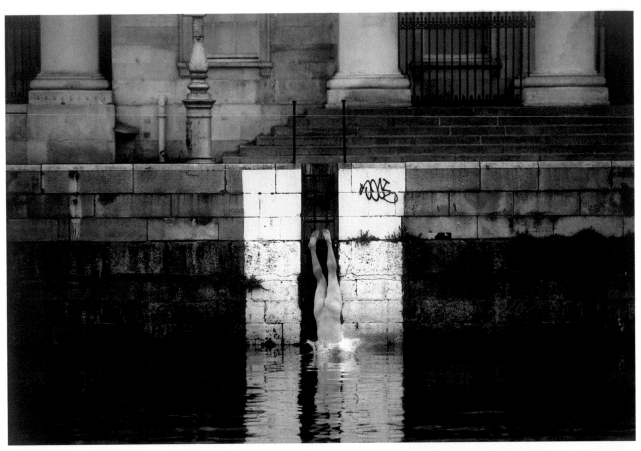

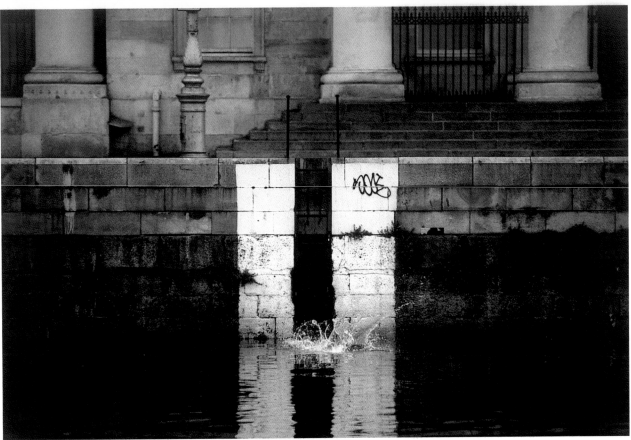

Chiasm

Dorothy Cross

In 1998 Fiach MacConghaile of the Project Arts Centre in Dublin asked me if I had any ideas for an off-site project while their building was being renovated. I have always loved handball alleys, and was intrigued by a sea pool called the Worm's Hole located in the Aran Islands off the coast of County Galway. I realised that the proportions of the pool mirrored those of the handball alleys.

There are more than 370 handball alleys scattered around Ireland, many are under threat of the demolition ball. Once popular, the alleys are now largely disused. They stand like modernist sculptures: beautiful, empty, roofless, cast-concrete arenas.

Poll na bPéist (The Worm's Hole) lies at the base of the terraced cliffs of Inis Mór. The exquisite rectangular pool is fed from beneath by the ocean, the water rising and falling with the tides and weather. A natural structure, it was formed geologically, and contrasted perfectly with the manmade structures of the handball alleys.

While driving on the road to Galway I found two perfect handball alleys in the grounds of a school, a strange architectural quartet of two alleys built against two. My idea was to project the film of the pool onto the floor of the alleys, spinning and swirling and never quite fitting or still, and to have a soprano enter one and a tenor the other, separated by the tall wall. They would sing fragments of operatic arias of love and loss. We filmed *Poll na bPéist* from 360 degrees and projected it from two 90-foot towers, filling the floor of the alleys.

I took a residency in Roches Point lighthouse for a month and listened closely to many romantic operas, gleaning phrases of the most intense exclamations of love and loss. I finally selected from ten operas sung in French, German, Russian, Italian and English from Monteverdi to Strauss, Gluck to Berlioz, threading the fragments together in a non-narrative structure. The singers sang without orchestration in each alley. They were isolated from each other, walking on the same projection, with the wall between them separating them like Pyramus and Thisbe, but without the hole.

We built a scaffolding structure for viewers to stand and look down into the alleys. It was never possible to view both singers equally, one's perspective depending on one's position. Each night one could choose to watch three repeated cycles of music. At times, the singers' voices blended as a fragment of duet occurred. "Adieu adieu de cet adieu si douce est la tristesse" (Gluck / Romeo and Juliet) seemed like the end, only to be revealed as the centre point when the cycle was repeated again. I did not choreograph the singers to arrive at a point together at the central wall, it was left to chance. They never did. They eventually ended where they began with "Ein schones war" (Strauss) and "Donna non vidi mai" (Puccini). For the three nights of the performance the skies remained clear, a full moon hanging in the sky between the alleys and the Aran Islands to the west, and bats flying above the singers' heads.

Chiasm 1999

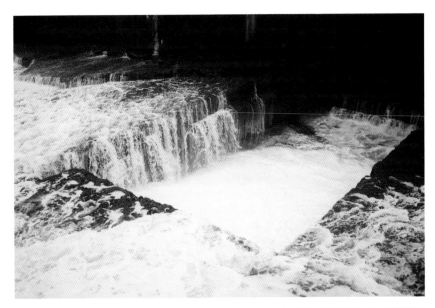

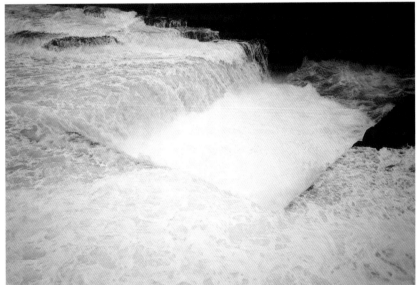

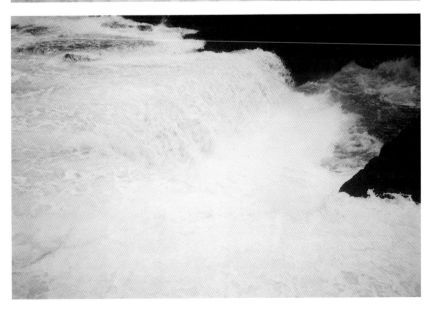

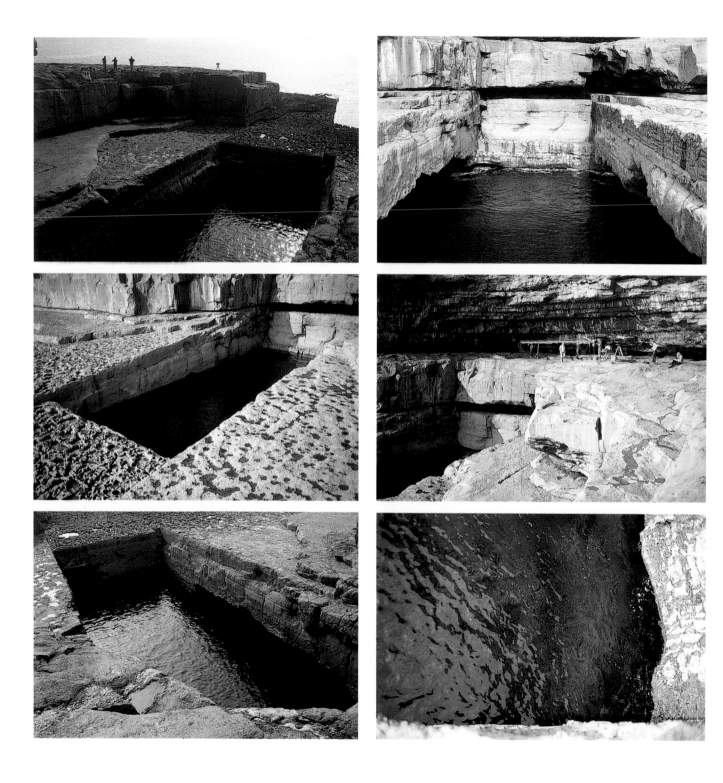

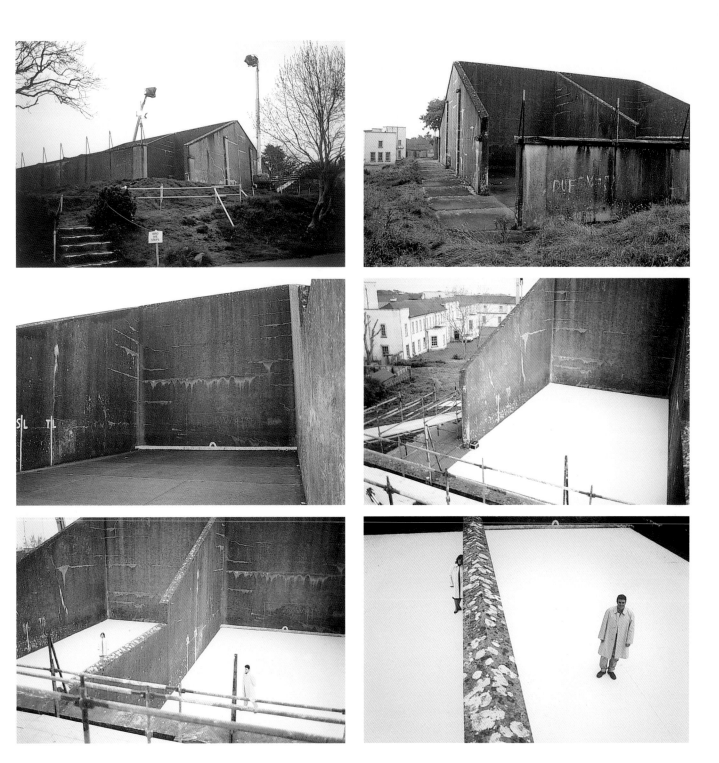

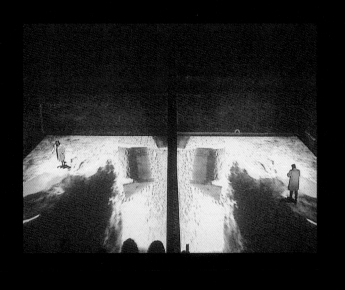
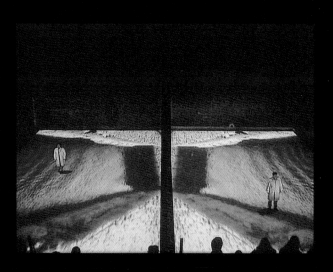
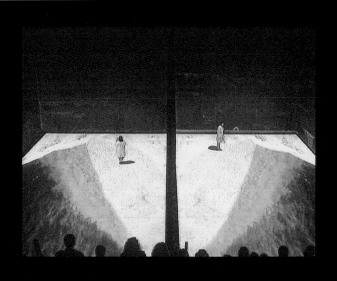
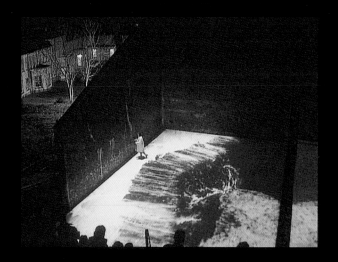
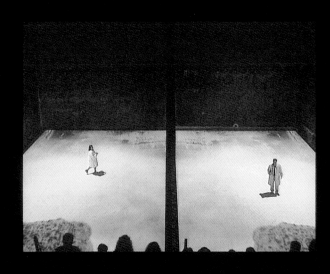
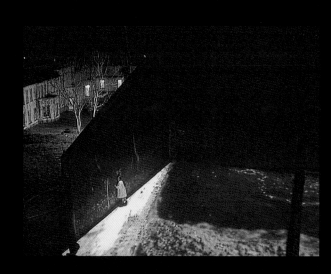

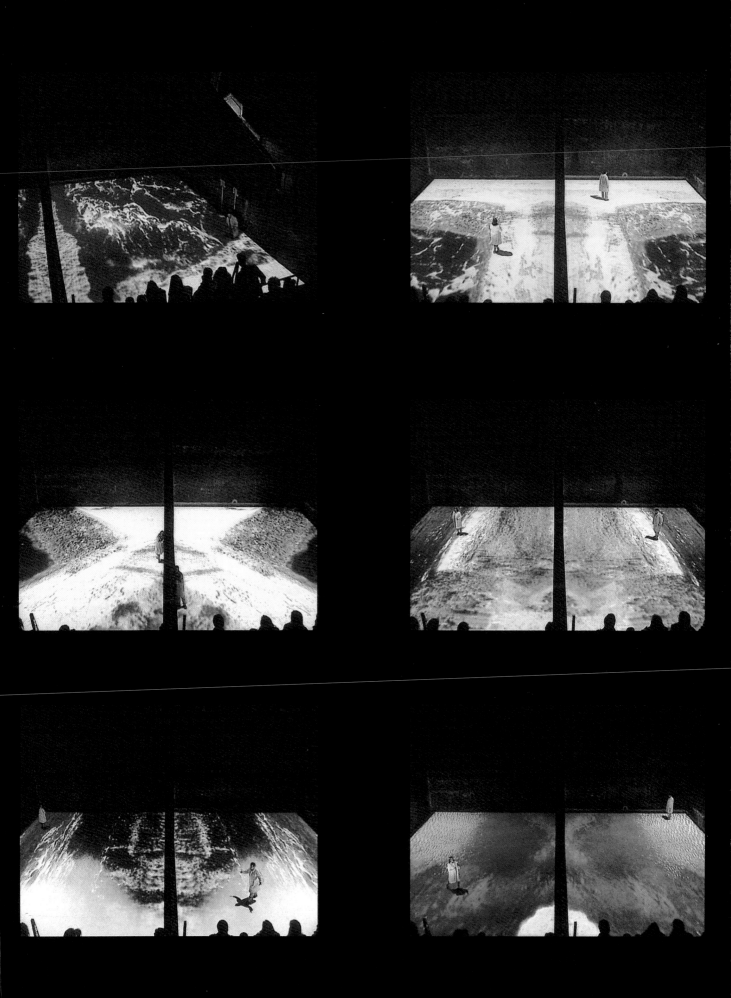

Ghostship

Dorothy Cross

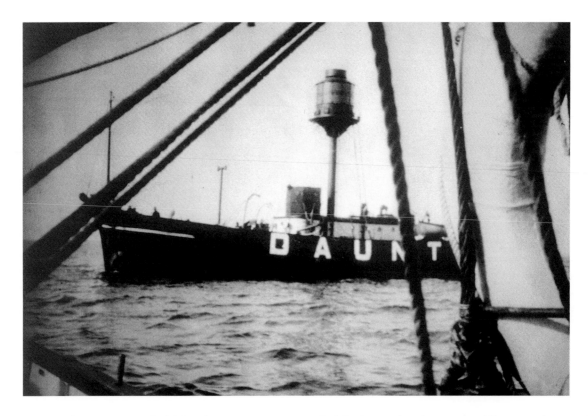

In 1999 an open submission was held for the Nissan Art Prize, a joint IMMA / Nissan award given biennially for an artwork to be located non-permanently in the Dublin area. For the previous six years I had cycled past a beautiful, redundant, red-painted lightship moored to a pier in the docklands, en route to my studio in an old powerhouse in the middle of Dublin Bay. I submitted an idea to create a ghost ship.

As a child the lightships were important, romantic, floating lighthouses that marked dangerous reefs around Ireland. The ships were engineless and moored to the rocks below, and were manned by light-keepers. The name of the reef was painted in big white letters on the red painted hull of the ships. One such lightship was located on the Daunt rock several miles off the south coast. Every summer our father brought us out in our boat to visit it, dropping off cigarettes and newspapers to the men on board. In the seventies the ships were decommissioned and replaced with satellite buoys, and now only three remain in Irish waters.

When I looked closer at the ship I passed every day

in Dublin I saw that it was the Albatross that my father had photographed on the Daunt reef in the thirties. *Ghostship* was chosen for the Nissan Art Prize. The logistics of making such a simple idea were mountainous: suddenly insurance men were hysterical, looking for ludicrous amounts in case the ship broke its moorings, in case it hit a passing ferry and in case the hull fractured. The Albatross was tugged to the ancient Dublin dry docks, beached, scrubbed and tested, and found to be sound.

Despite all, *Ghostship* happened, thanks to the many people who worked on it with me. The phosphorous paint was sourced in Germany and was able to glow for up to twelve hours. It was incredibly expensive so it had to be applied like gold dust. A light rig was built and attached to the hull and super-structure and UV lamps were attached to a timer that boosted the ship with light every ten minutes. We moored the ship in Scotsman's Bay in Dun Laoghaire for three weeks. It glowed and faded and eventually disappeared into blackness when the cycle of light ended.

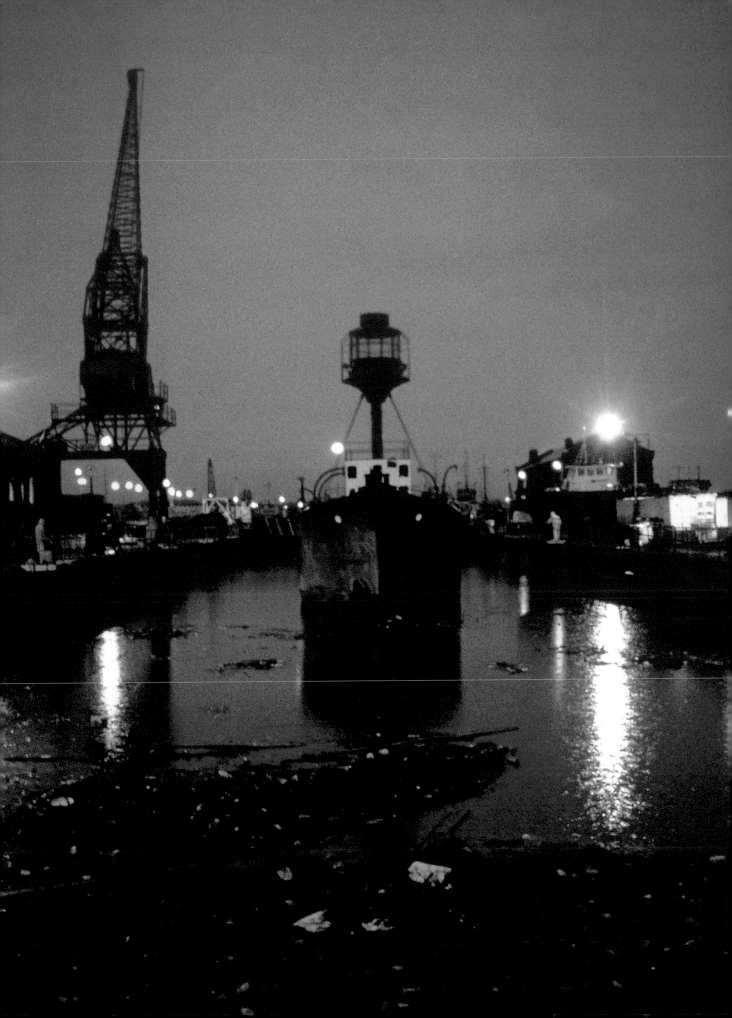

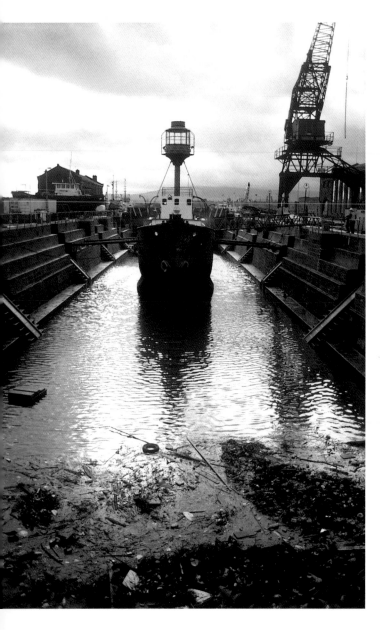 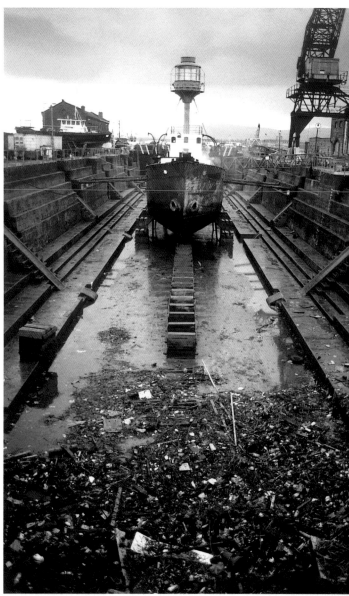

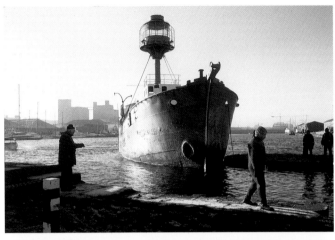

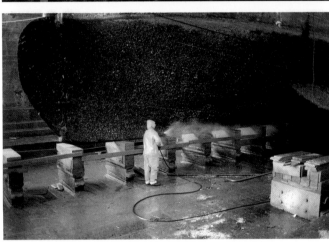
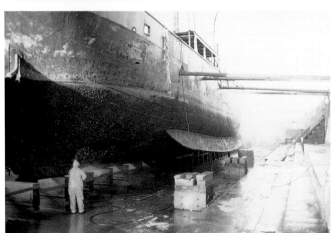

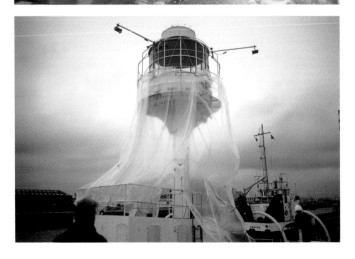

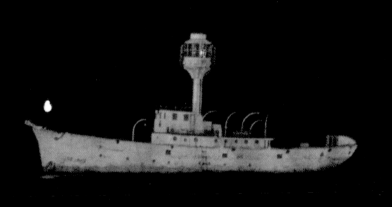

Medusae
Tom and Dorothy Cross

In 1999 a friend told me the story of Maude Delap, an amateur naturalist who lived on Valentia Island from 1866 to 1953. She succeeded in breeding jellyfish in bell-jars in her father's house in 1902. I was fascinated by the story.

I heard about funding from an organisation in London called SciArt who were looking for artists and scientists to work together. I called my brother Tom who is a zoologist and had been my swimming coach and asked him if he would like to collaborate on a project about jellyfish. We decided that I would research the story of Maude whose life is now a memory while he researched the swimming systems of a jellyfish called *Chironex fleckeri*: the deadliest and fastest swimming jellyfish in the ocean. It inhabits the waters of north Australia. Our subjects mirror each other—little is known about the life of Maude Delap or the life of *Chironex fleckeri*.

Maude Delap was the daughter of a Church of Ireland Minister, and from a family who were passionate observers of nature. Maude had a correspondence with the Natural History Museum in Dublin throughout her life, sending specimens she found on the island—including a live turtle—to Dublin on the train. She was offered a job in Plymouth, but due to the fact that she was unmarried, she was not permitted to leave home. In 1898, she met a group of British scientists who were doing a flora and fauna study on the island. She fell in love with one of them, but he did not fall in love with her. She sent him a bunch of wild violets every birthday until he died. The logistics of breeding jellyfish required Maude to go out to sea every day in her small punt, drag-netting for plankton to feed the jellyfish. She kept exact and detailed records. Maude never had access to the underwater realm of the jellyfish: she used a fish-viewer; a cone-shaped instrument with a glass bottom that she held on the water surface over the side of the boat.

One hundred years later, my brother's fieldwork differed little from Maude's. We travelled to Australia and netted *Chironex fleckeri* on the beaches of northern Queensland. These creatures are so transparent that often they are first seen as shadows on the seabed. They have twelve eyes at the corner of their bodies, but no brain and have killed more people in Australia than sharks and crocodiles combined. We filmed them in tanks wearing singer-suits, building rigs of Plexiglas with grids to provide scale. The animals were introduced at one end and released to swim at right angles to the camera. Later, computer analysis was made of the jet-propulsion system of swimming. Tom took the first ever DNA fingerprint of *Chironex fleckeri*, which will enable a genetic study of the population throughout its territory. *Medusae* is a strange hybrid, a short video moving from 1902 to 2002, from memory to the unknown, the work occurs at the point where the territories meet like reflective opposites.

p. 90

Rhizostomae photographed in
Berlin Aquarium

Chironex Fleckeri in the wild,
Australia.

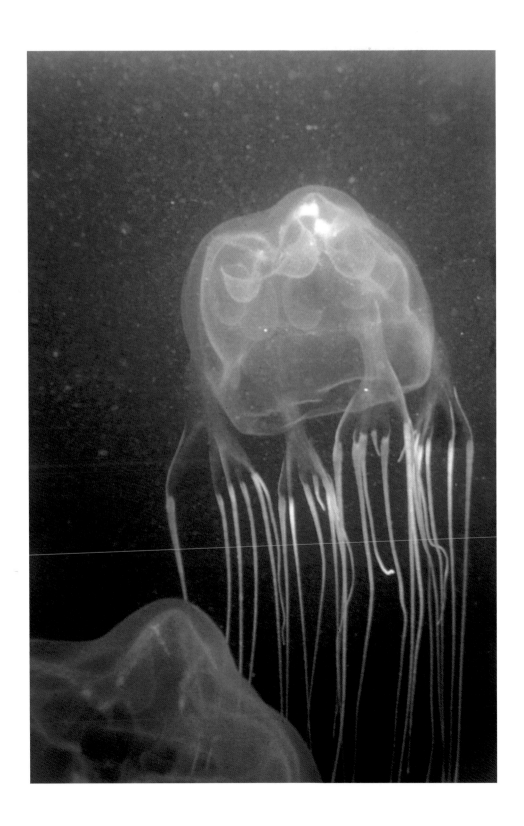

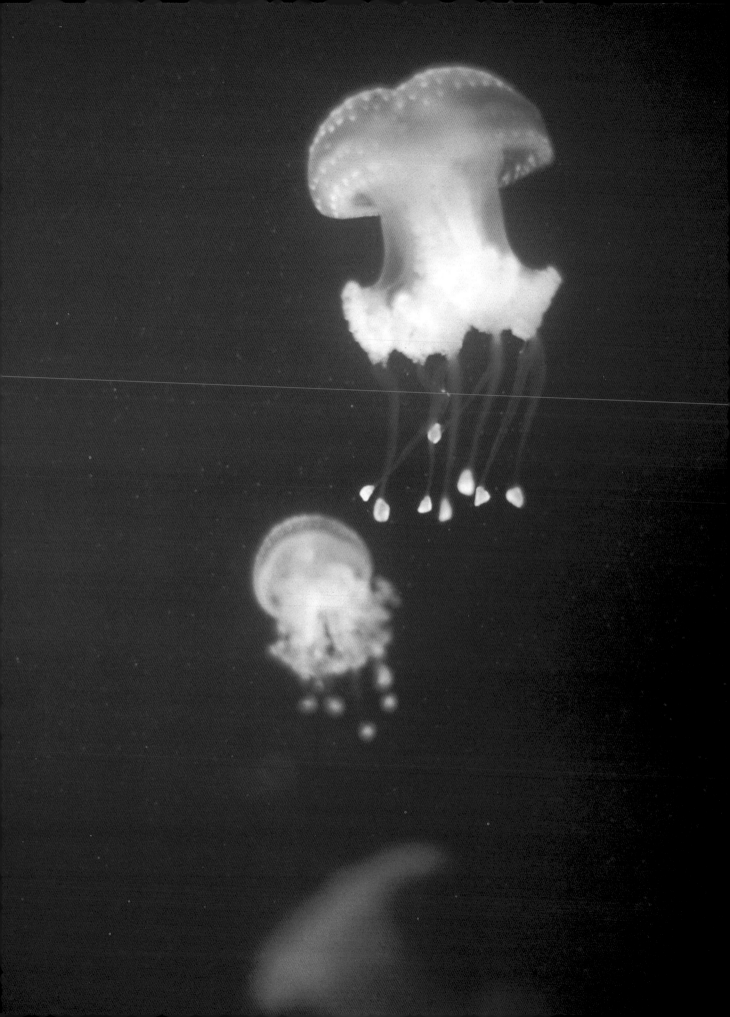

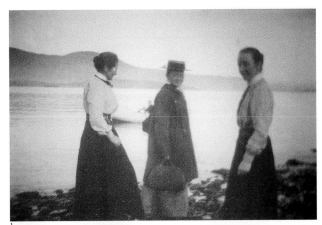

1

1. Maude Delap with her sisters
Mary and Connie, ca. 1897

2. Whale skull on a table,
Reenellen House, Valentia Island,
Co. Kerry, 2002

3. Connie Delap and whale skull
on a table, the garden, Reenellen
House

4. Maude Delap with her mother
and sisters, Reenellen, ca. 1897

5. Maude Delap 1866–1953

2

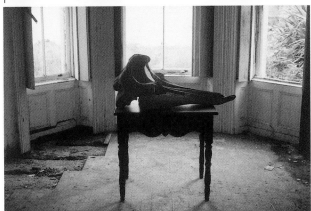

3

4

5

1. The Natural History Museum, Dublin

3. Cabinet of turtles, Natural History Museum, Dublin

5–6. Glass models of jellyfish by Leopold and Rudolf Blaschka, Natural History Museum, Dublin

2. Whale skull donated by Maude Delap to the Natural History Museum, Dublin

4. Small turtle donated by Maude Delap to the Natural History Museum, Dublin

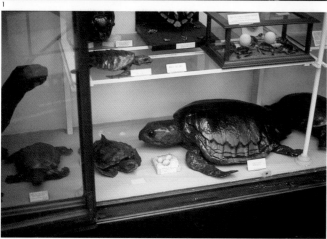

1

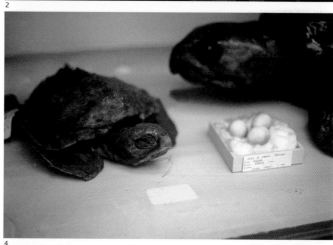

2

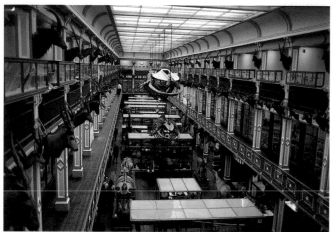

3

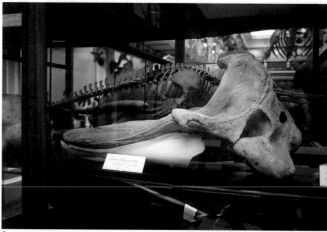

4

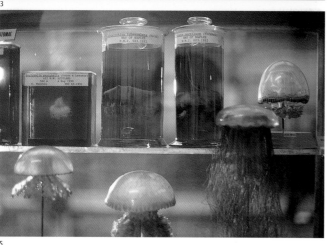

5

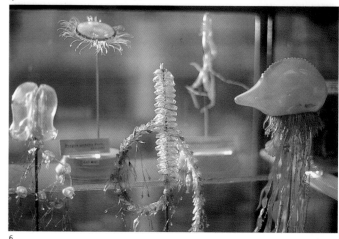

6

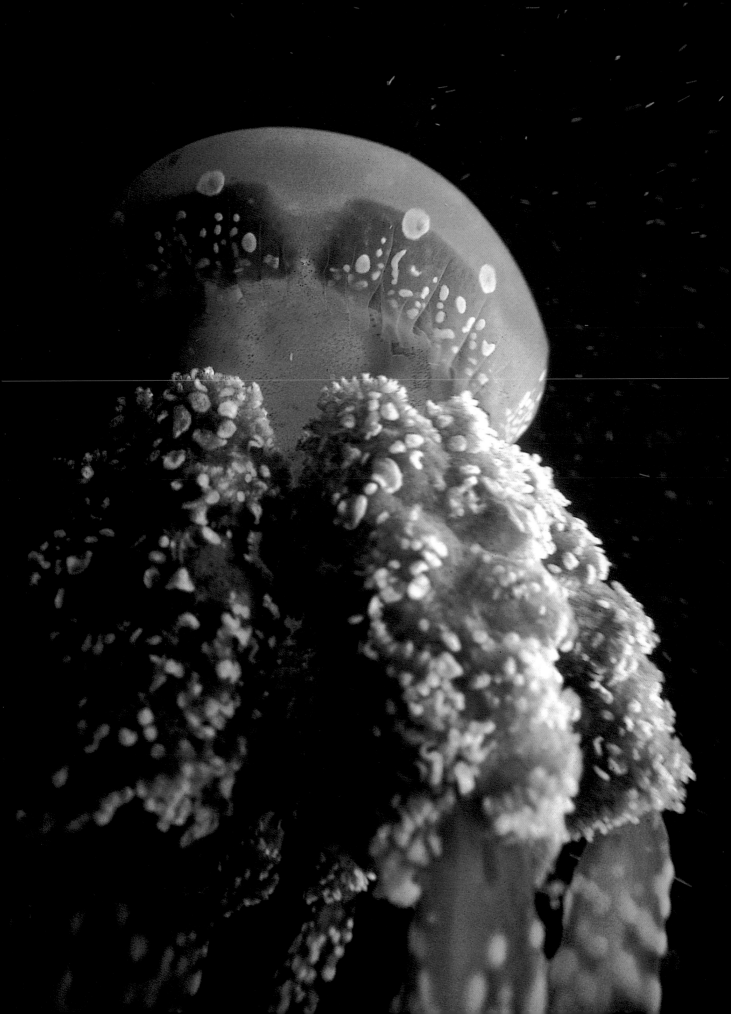

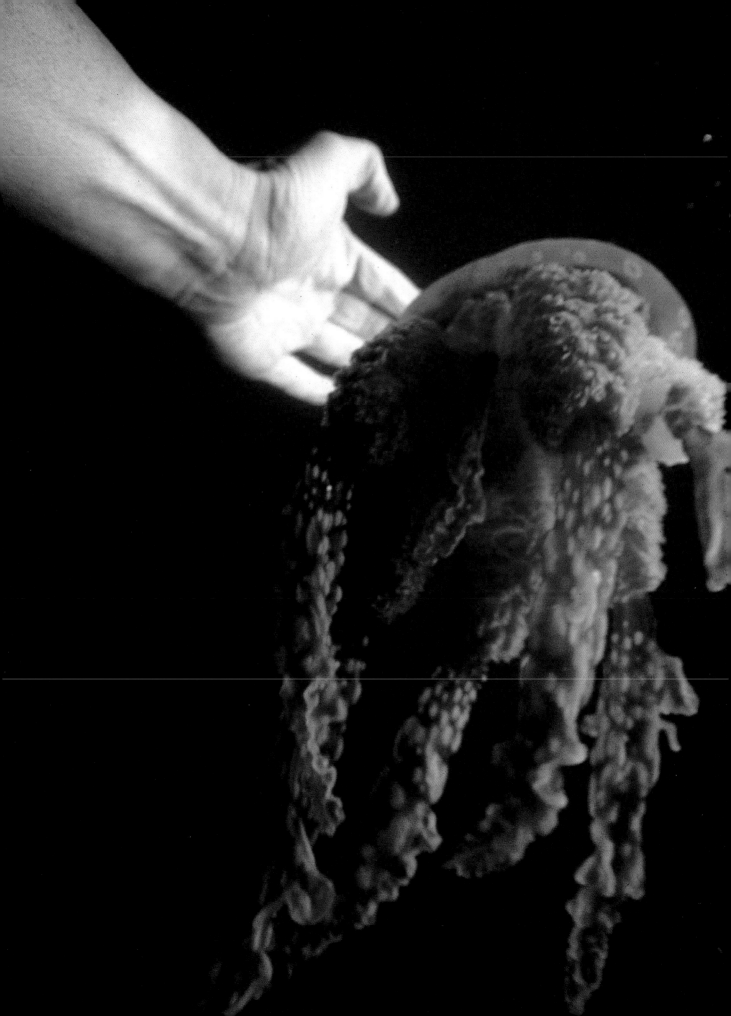

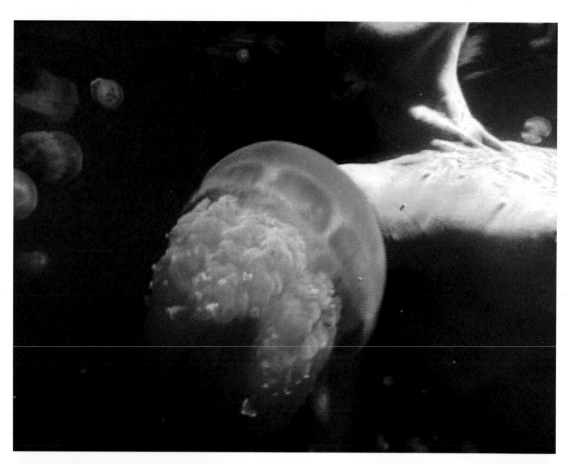

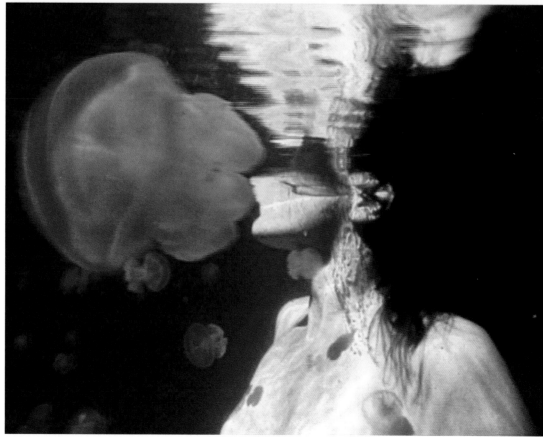

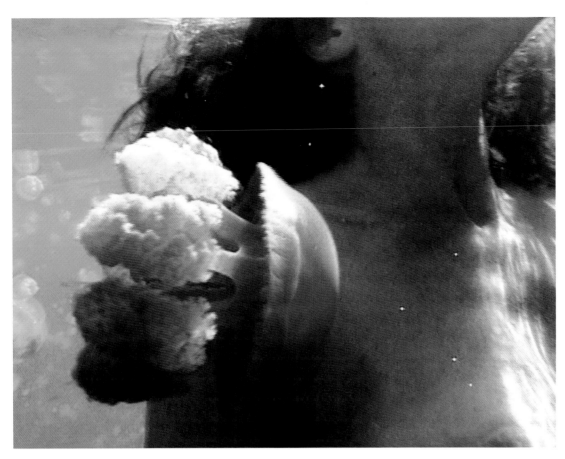

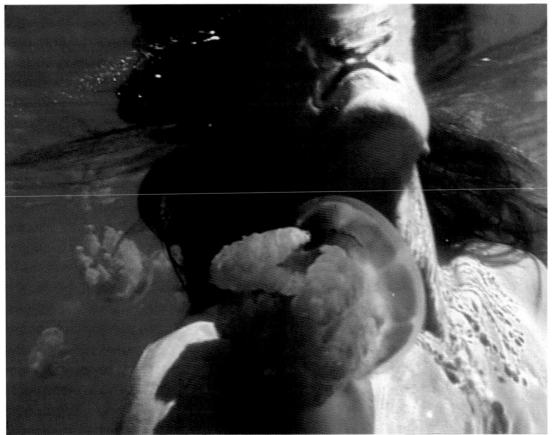

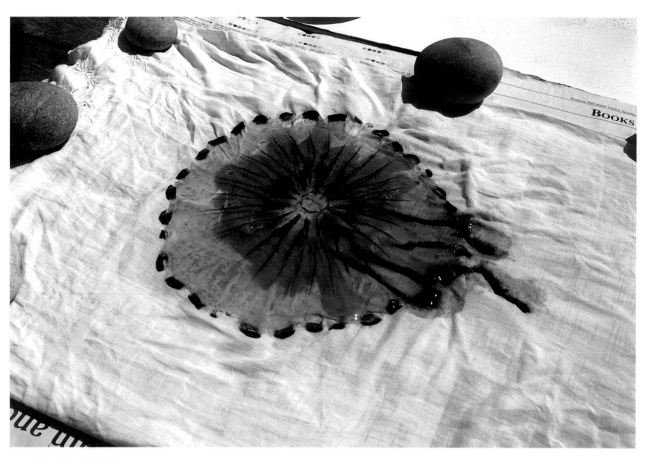

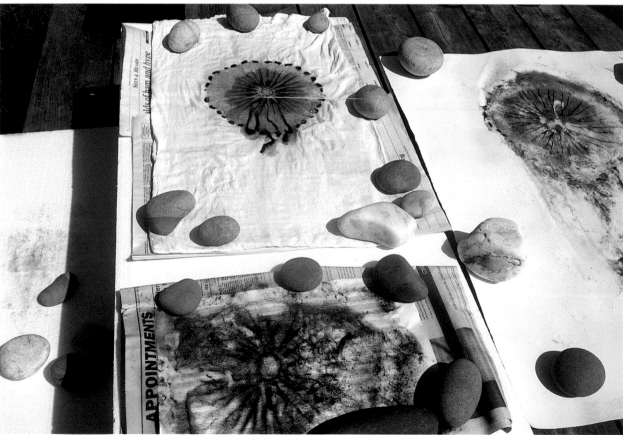

Drying Jellyfish,
Connemara, 2003

Jellyfish Drawings 2003
Jellyfish on paper (*Physalia,
Chironex fleckeri*)

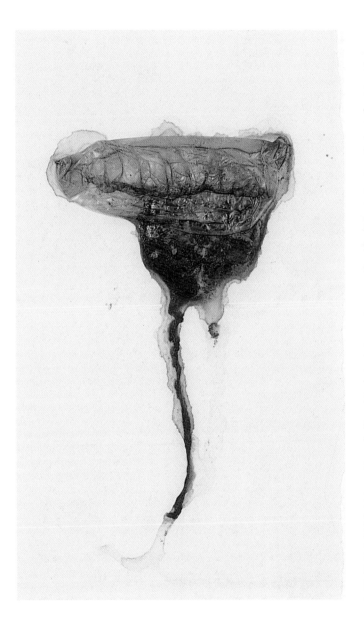

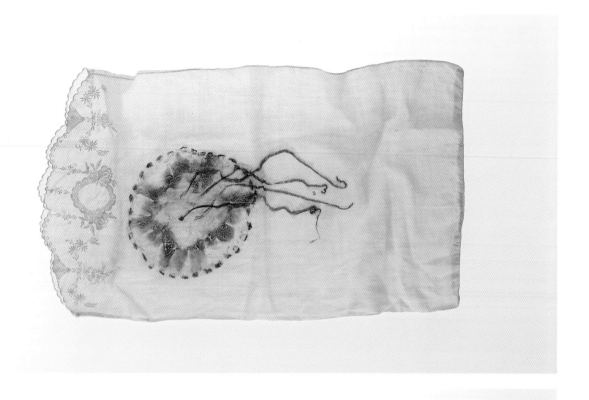

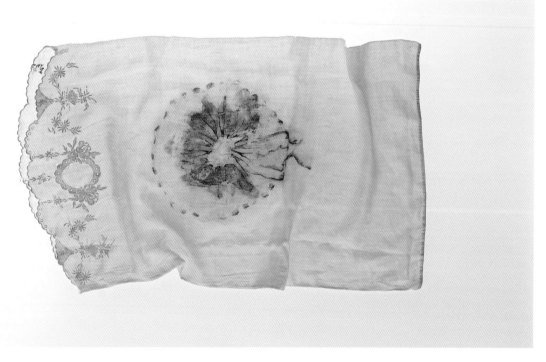

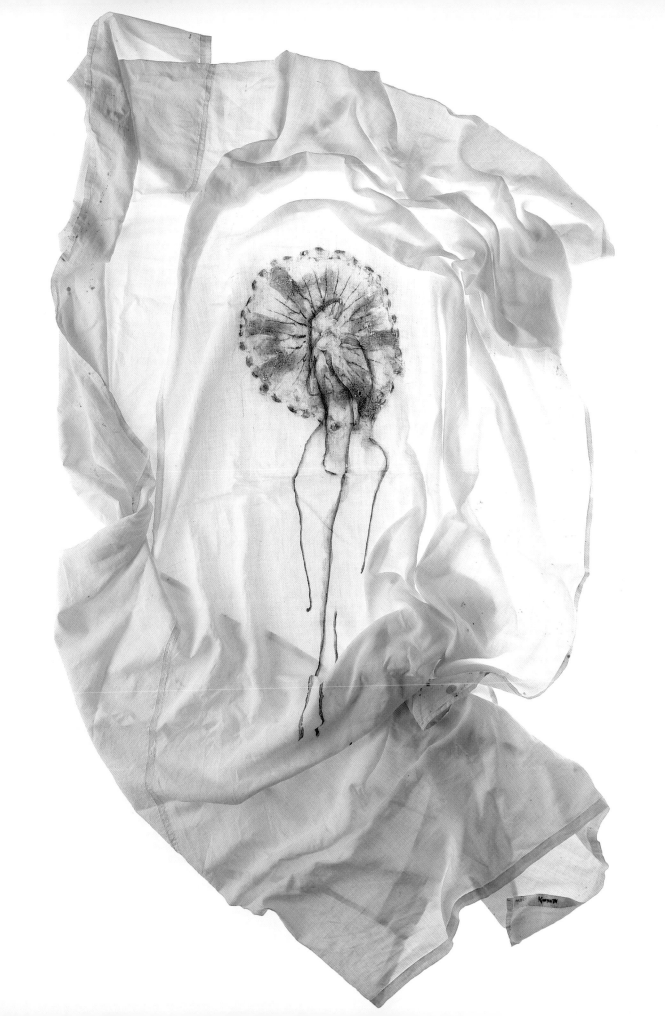

Natural History

Patrick T. Murphy

Dorothy Cross's objects harbour an explosion of associations. It is the artist's skilful concentration on the formal intertwined with the deeply personal that sets her fully in control of the myriad interpretations of her work that might occur, without declaring for or curtailing any one. It is Cross's ambition to create a complex and multifarious world where interpretations can never be still, but circulate and oscillate between degrees of insight and confusion.

The application of psychoanalytical criticism has been used to decode her work and though it informs the orchestration of her imagery it cannot alone possess or explain the images. The placing of the work in the art historical canon of Surrealism again points to some of the technical dynamics employed in conceiving the physical work, but simplifies rather than elucidates the complexities of gender, sex, love and death as treated by Cross. Semiotics again offers useful insights into the history and cultural development of certain iconographies employed by Cross, extending the reach and sophistication of the work. In a Talmudic sense, there could easily be a commentary on the commentaries on Cross's work, but the artistry is in the genius of combining factual and fictional potential, of object found or transformed and its ability to support and expose a generous reading.

The disruption of the conventional, the transposition of attributes, the emphasis on the container as much as the contained, the juxtaposition of elements all return again and again in Cross's work. These are her formal mechanisms but her initial motivation comes from a passionate engagement with nature, infused with the temperate calculations of scientific observation. Her perception is curiously democratic—everything is scrutinised with the same rigor whether it be an inert object or a fully functioning mammal.

Such an intense curiosity could not be expressed by any single signature style but is carried by a variety of strategies bound by a sensibility whose formalism and sentiment is rare in contemporary practice. Cross moves easily and often concurrently from the operatic to the haiku—from large collaborative projects to objects made on the studio table.

Cross returned to Dublin in 1983 after completing an MFA at the San Francisco Art Institute. Prior to that she had completed a foundation year at the Crawford School of Art in her native Cork followed by a BA at Leicester Polytechnic in England. She set up studio in her basement apartment of an Edwardian redbrick. Her work quickly emerged with a solo exhibition at the Triskel Arts Centre in Cork in 1983 and her Dublin debut followed in 1985 with a solo show at the prestigious Hendriks Gallery. The latter exhibition entitled *Contraptions* consisted of wooden constructions combined with found objects that lampooned the church spire with its ecclesiastical and phallic connotations. Cross's early declaration of an interest in architecture was to point to an abiding awareness of its power both as subject and as context and the confluence of the two.

In *Ebb*, her installation at the Douglas Hyde Gallery in 1988, Cross created a stage of interpretation through the careful consideration of architectural context and the theatrical blocking of elements. One entered *Ebb* by descending the staircase of the Gallery and meeting a constructed wooden ramp just before the last few steps. This ramp reached jetty-like out to the middle of the space in a slow modulated slope, ending at ground level in a half turn. Once delivered beneath the architecture of the gallery, the visitor encountered a series of sculptural constructions made from wood, steel, brass and found objects. The maritime theme of its title was carried into its central form, *Shark Lady in a Ball Dress* (1988). This work combined all of the elements central to much of Cross's past and present exploration. An archetype of aggression, the shark was accentuated with breasts and standing upright with half of its body emerging from a woven bronze dress—the upper torso flicking from shark to phallus, from beauty to danger. This, however, is only one element in a grouping of objects crazed with titles such as *Mr. and Mrs. Holy Joe, Erotic Couple, Mother*. These figures occur ensemble, addressing each other, forming couples, loosely or literally bound, working together and individually. One is led into a milieu, at once central and indifferent to our concerns.

The found object is central to her method and can be divided into four categories: the traditional *object trouvé* rescued from its prosaic functionality and catapulted into poeticism by its placement in a new context; the historical object, owned by the artist and accompanying her since childhood to await her discovery of its

Ebb 1988

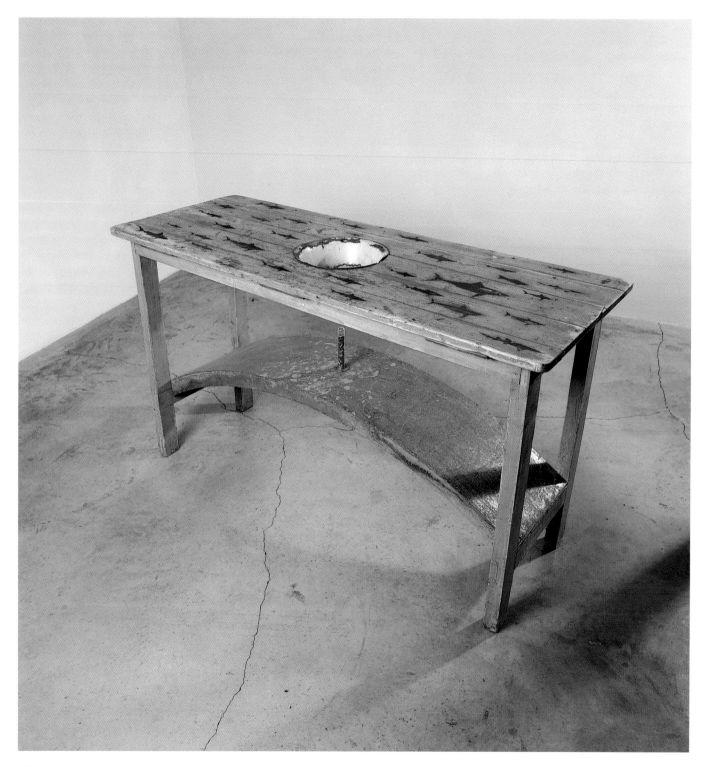

meaning; others, remembered by the artist and acquired at a later time; and non-objects incorporated or used in much the same way, ranging from an aria to an individual. In all, Cross is enchanted firstly by their strange beauty and secondly by their pathos.

In 1990, Cross was invited by the Artscape Nordland Project to visit the upper coastal region of Norway to create a work in a series of commissioned projects that also included artists such as Dan Graham, Luciano Fabro and Christina Iglesias. During her reconnaissance, Cross found an object hanging in a local museum that was to open up a whole new range of work. The udder sieve was a cow's udder stretched onto a circular wooden frame and perforated to act as a domestic sieve. The artist was stimulated by the use of the udder for something other than nourishment. The project conceived for Nordland was *Shark, Cow, Bathtub* (1993). Sited on a fjord, it picked up on the region's economic staples of fishing and dairy farming. Cross made a bronze cast of the local blue shark, adding breasts causing a similar transformation to that achieved with *Shark Lady* (1988). The cast was stranded above the tide line, beside it lay a large boulder of imported pink granite crowned with a carved set of udders. The bathtub, made from cast iron, the mould coming from the tub in her family's seaside home, was intentionally placed in the mid-tide line, filling and emptying with the tidal ebb and flow and exposing its domesticity to the ravages of storms and the dangers of the consuming sea. Indeed, two years later it was to disappear into the ocean leaving only the *Shark* and *Cow* behind.

The exhibition *Power House* (1991), an installation at the Institute of Contemporary Art in Philadelphia, arose out of the context of the artist's studio at the time. Cross then occupied a section of the old Pigeon House electrical generation station situated in the southern docklands of Dublin Bay. In the early seventies, a new station had been built adjacent to the old building. From the evidence remaining in the old station, it seemed as if one morning one was switched off and the other on, its working population simply moving from one to another. The site was cavernous—huge turbine halls and labyrinths of rooms. Within all of this, Cross secured the relatively intact Pump House. Some of the early cowhide and udder works began to be made in this studio, one

small area tented with plastic sheeting to offer some hope of a heated area for winter work. An early experimental version of *Virgin Shroud* (1993) was made there, a life-size cowl made from cowhide, mimicking the form of the traditional Virgin statue, its crown formed by its four udders.

Concurrent to this object-making, Cross was exploring the gigantic structure of the power station. There was both a legal and psychological scent of trespass to this endeavour. The former in that the site strictly forbade entry due to the dangers inherent in its dereliction, the latter that a lone female was now rediscovering this male preserve of industrial power. The plunder was to yield works such as *Parthenon* (1990) and *Control Room* (1990). In *Parthenon*, wooden lockers mimicked the classical colonnade. Their half open doors offering glimpses into the residue of their users going back as far as the thirties. Inside, Athena was replaced by an iron bed and constructed wire mattress. A phallus formed within the mattress's rusted grid, the matrix also supporting shards of broken control gauges. The image was jarring, hard, violent yet vulnerable. *Control Room* appropriated the actual panels from the station. A crescent-shaped desk with dials and Bakelite knobs and switches stood in opposition to a series of wall-mounted photographs of the phases of the moon. In both works the manmade stands in relation to natural forces, sexual and lunar.

The next studio could not have been more different: accidentally found, then offered by the owner for a peppercorn rent until he was ready to restore it. It is an important building for Modernist architecture in Ireland, designed by Ronald Tallon of Scott Tallon Walker Architects in the sixties. The Glasshouse is a Miesian box with an outrageous cantilever out over a small river gorge. Mildew and damp had invaded its once pristine state, spoiling its now fractured plate glass windows. The artist once described it as having a "used glamour".[1] Cross maintained a studio here for four years and it was in this studio, surrounded by enlarged photographs of the tender gestures of rugby players, that I first spied the trunk (*Trunk*, 1995). It sat as a remnant from another place and time, more wooden box than trunk. Its stained surface echoed the discoloured windowpanes. Inside was nothing but a pair of whitish knickers with a dried out

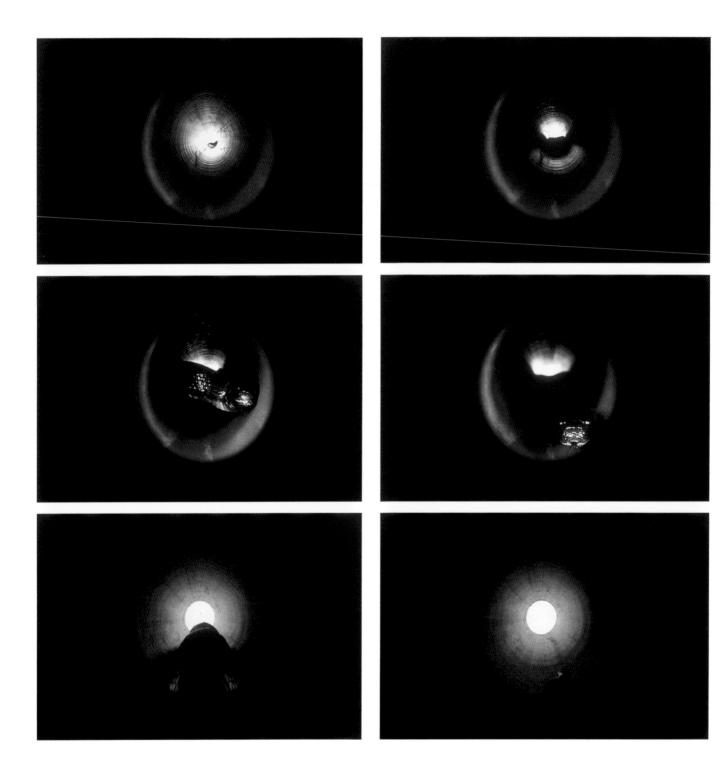

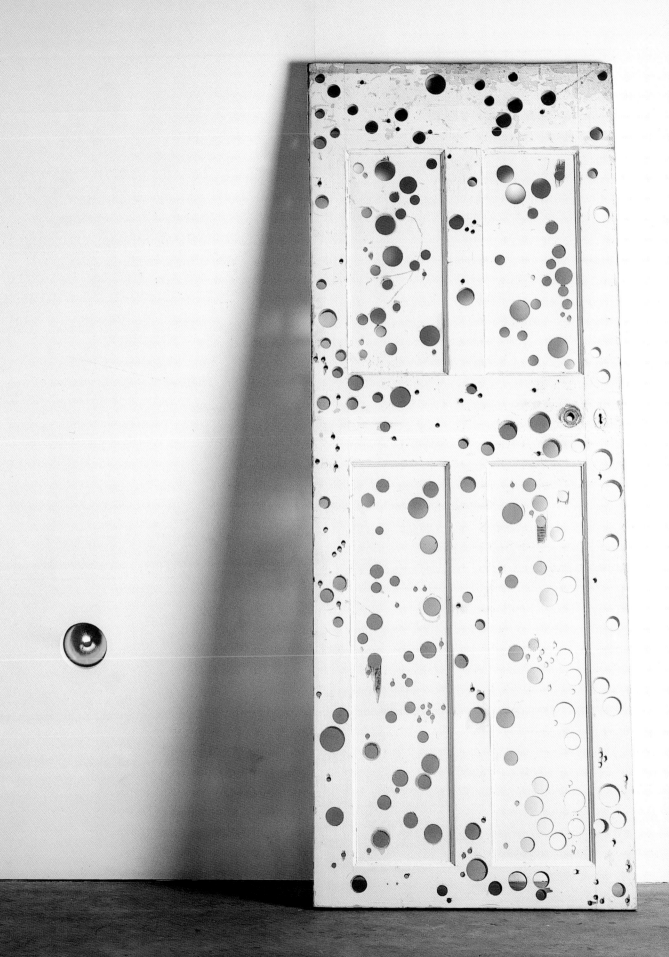

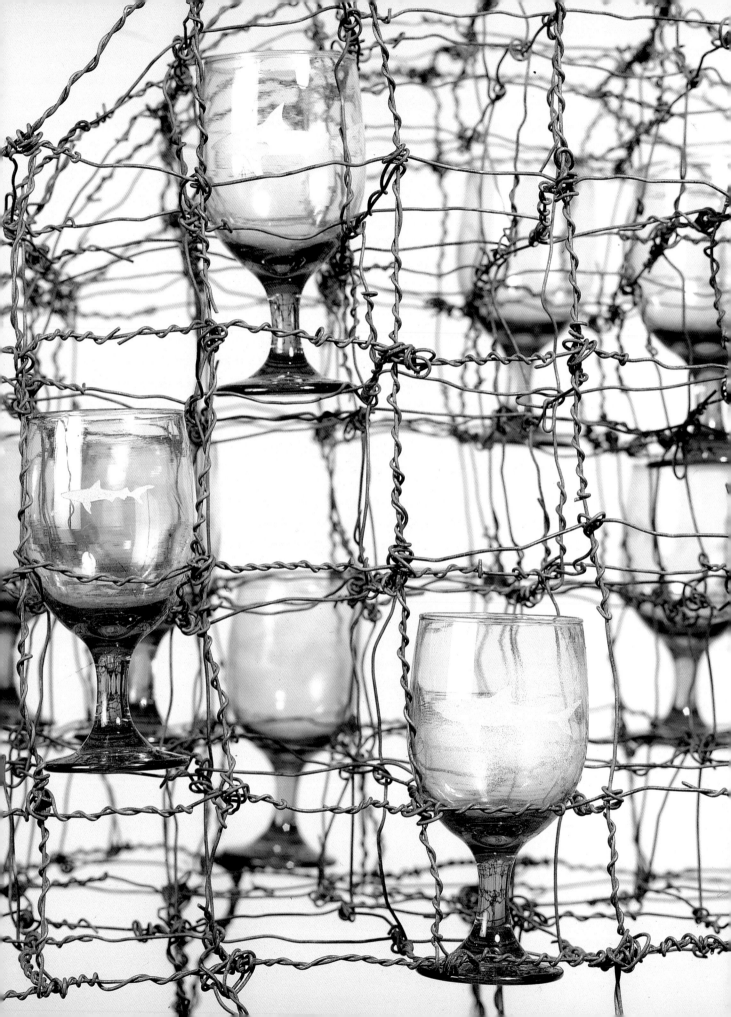

cow's teat sown into the gusset. The effect is chilling, aimed at the nervous system rather than the cortex. First, there is the transgression of the actual discovery, peeping inside the box, a privacy invaded. Then, the paradox of the protruding, maternal text, with the inserted, phallic force. This work skillfully displays Cross's ability to produce an object that crackles with meanings and evades any one reading. Also made in this studio was *Bible* (1995), an illustrated Bible, discovered in the family attic and retained by Cross until its function presented itself. In this case, the artist carefully drilled a round hole, an inch and a half in diameter, through the entire book. Its fortuitous appearance in the illustrations transform their quaint Victorian nature into a very contemporary comment on religious iconography in a secular age (the insertion of the hole is reminiscent of Robert Gober's use of a storm drain inserted into a statue of the Virgin Mary). It is an iconoclastic gesture toward a poignant reinvestment of physicality into images that assert the spiritual and the heavenly.

In an interview with Frances Colpitt[2] for the publication accompanying her residency and installation *CRY* at Artpace in San Antonio, Texas in 1996, Cross likens the installation to a cathedral—with a central tabernacle and transepts to each side. The main architectural component was a room-size metal refrigerator. The fridge contains the coiled dead bodies of various species of snake. Snakes had entered her vocabulary a year earlier when in 1995, while attempting to stuff a pair of snakes, Cross unexpectedly discovered their hearts. This accident led her to abandon the original concept; instead of stuffing the snakes, she had silver reliquaries fabricated to contain their desiccated hearts. *Lover Snakes* (1995) showed the two snakes with their dark mummified bodies intertwined, the silver reliquaries knotted into their embrace.

Taking the various mythologies and symbols attached to snakes, it seems both disarming and reflective to assign the emotion of love to them. Of course as well as the sentiment of this work, the next most obvious fact was that they were dead. The extrapolation of death was central to her Texas installation, *CRY*, the title an abbreviation of *cryogenics*. The enormous refrigerator provided an industrial style mausoleum for the dead snakes as they were held in suspended animation and

the hope of future rejuvenation. Cross's commentary here on an American attitude to death is not satiric or ironic, its title tells us that in the face of our unavoidable mortality, rage and resistance prevail. Outside and to the sides of the fridge were a series of objects and spatial interventions sited in the metaphorical transepts. *Kiss* (1996)—also of cast silver—was created out of the space that occurs when two mouths are locked in unison. This is not the embodied kiss of Rodin or the stylised embrace of Brancusi; this is the negative space, evidence of the intimacy that has taken place. Cross refers to this as the "emotive pivot"[3] of the show.

In 1997, following her Texas residency, Cross returned to Dublin and located a run-down, disused sewing factory. It was a loft style space on the top floor of a nineteenth-century industrial building. "Foley Street" as it was referred to in conversation, needed a great deal of renovation to act as both her residence and studio but within the next two years it was to see the conception, research and preparation of two of the most important public art events of the decade.

Ghostship (1999) appositely displays Cross's decisiveness

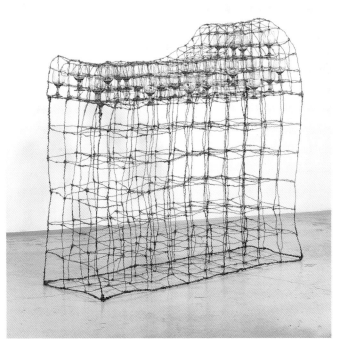

 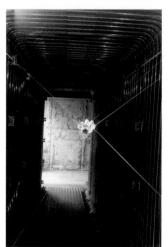 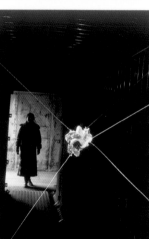

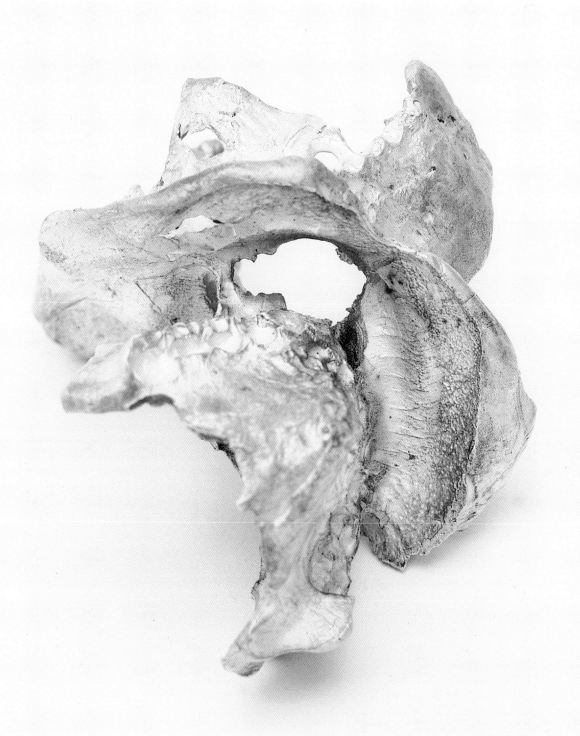

in choosing an object that shears into and from the psyche of the general audience. The ship in question was not the square rigger of folk tales, but a lightship that once warned of the dangers of a reef off Roches Point near to where Cross was reared, an *object* remembered. The lightship is a strange piece of nautical architecture, for though it employs all of the design elements of a ship it has no propeller and must be towed to its anchorage. There, immobile, it lights the way for those making passage, saving them but unable to save itself. Cross found the ship lying obsolete in the Dublin docks. The artist painted the hull with phosphorescent paint, and using an out-rigged structure she was able to boost the paint with large UV lights, which, when extinguished, allowed an eerie green glow to emanate from the ship. The lightship was towed to a prominent mooring on the south of Dublin Bay. The project, part of the Nissan Art Project organised by the Irish Museum of Modern Art, was incredibly successful and popular with crowds lining Dun Laoghaire piers to witness the event. Cross demonstrated her ability to pluck a cliché from public consciousness and represent it in a way that shows its impossibility and relevancy. The exposing of the mechanics of the trick—the lights and paint—did not detract from the breathtaking illusion, the seeing of a ghost. This exposé of effect occurs again and again in Cross's work and in some way stands in critique of those who restrict value to scientific method. This artist embraces both the rationality of scientific observation and the relevance of reverie.

Scattered throughout the Irish landscape are handball alleys. As ubiquitous as the parish Gaelic Athletic Clubs that built them, these are distinctive, instantly recognisable buildings made of cast concrete and roofless. For some time in the nineties Cross began to pay attention to these alleys, admiring their simple geometry and the obedience of form following function. Once found, these objects lay in her arsenal for some time before their extraordinary debut in *Chiasm* in 1999. Another natural piece of geometry was combined with the manmade alleys. On Inis Mór in the Aran Islands occurs the massive blowhole, *Poll na bPéist* (The Worm Hole). Here, the limestone rock has yielded to the tides from beneath to form a perfect rectangle. Cross filmed the pool as the surging tide rose within its walls.

Locating a double ball alley on the outskirts of Galway city, Cross projected the film onto the floor of these side-by-side courts. Occupying each space was a singer, a soprano and a tenor. Each sang fragments from selected romantic operas, arias that celebrated and lamented newly found, unrequited or lost love. Depending on the position on the viewing platform one saw and heard one singer or the other more clearly but never with equal strength. Neither singer could hear the other or be aware of their position on the court, as they were divided by a twenty foot wall. The combination of the architecture, the surging tide and the music created an acute reflection on the ebb and flow of love, its intense passion, its extreme loss. Love is not a subject that rests easy with contemporary art, many fearing its mine-field of sentimentality, but Cross shows her skill of circumnavigating the cliché and rejuvenating and representing it with a compelling authenticity.

There are works made by artists that are revelatory. Pieces whose generosity immediately offer an insight into an artist's sensibility when before you might have only found obscurity. Vija Celmins's *To Fix the Image in Memory* (1977–1982) consists of eleven found stones shown paired with their painted replicas. Its ruminations on art, materials and materiality, attention, loss and skill reflect on many of the themes that have occurred throughout Celmins's career. Likewise with a film made by Cross in 2000, and originally conceived as a public projection for the *Fourth Wall* series at the National Theatre in London, the *Eyemaker* (2000) is an eye opener. The subject, a professional ocularist from London, sits behind his worktable in the foreground a Bunsen burner and rods of glass. The false eye is created through the blaze of flame and the inflation of breath; the work teems with association but is realised in a deadpan way. The camera is confined, with only a few close-ups of the manipulations of the glass. There is no soundtrack except the blasting of the flame.

The white ball is blown and carefully added to with coloured rods to form the pupil and iris. The flame causes it to contort out of shape, the breath cooling it back into the ocular orb. Its verisimilitude is heightened by the adding of tiny veins at the end of the process. And with the eye fully realised it is blown larger and larger until it bursts and disappears. The treatment of

Screen / Ladies Changing
Room 1991

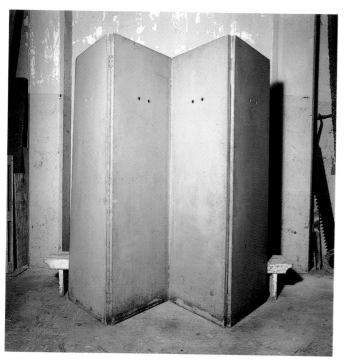
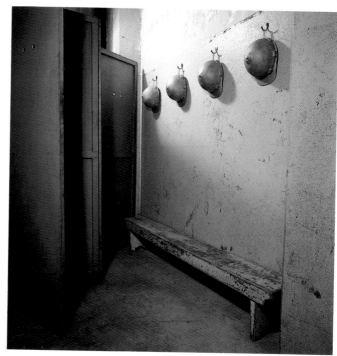
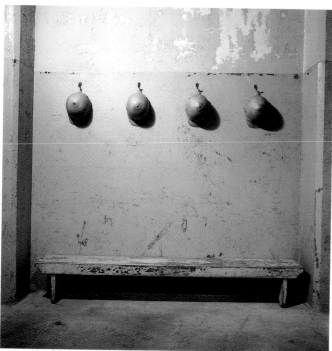
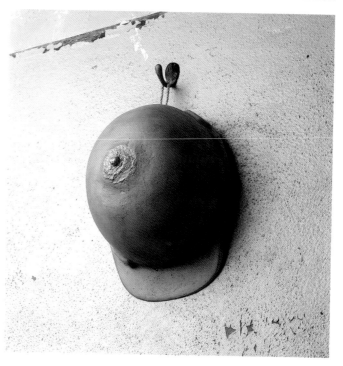

Power House, ICA Philadelphia

Control Room 1991

Heart Chair 1991

Parthenon 1991

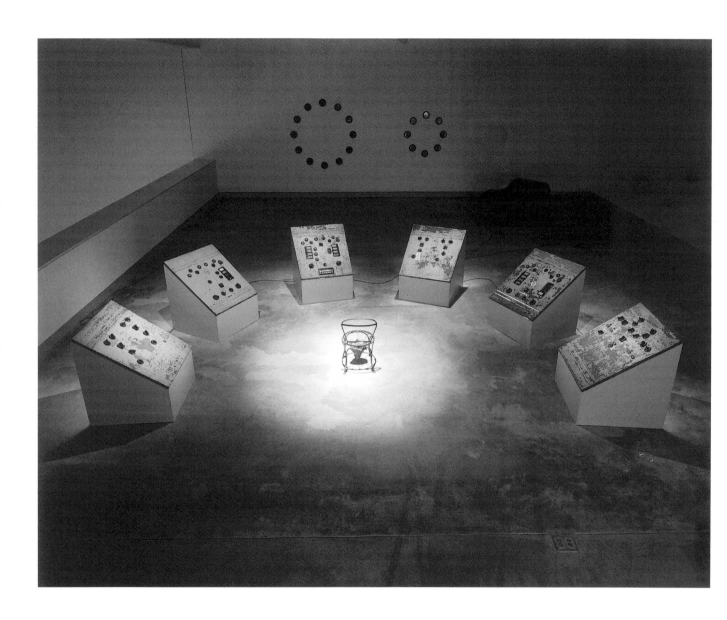

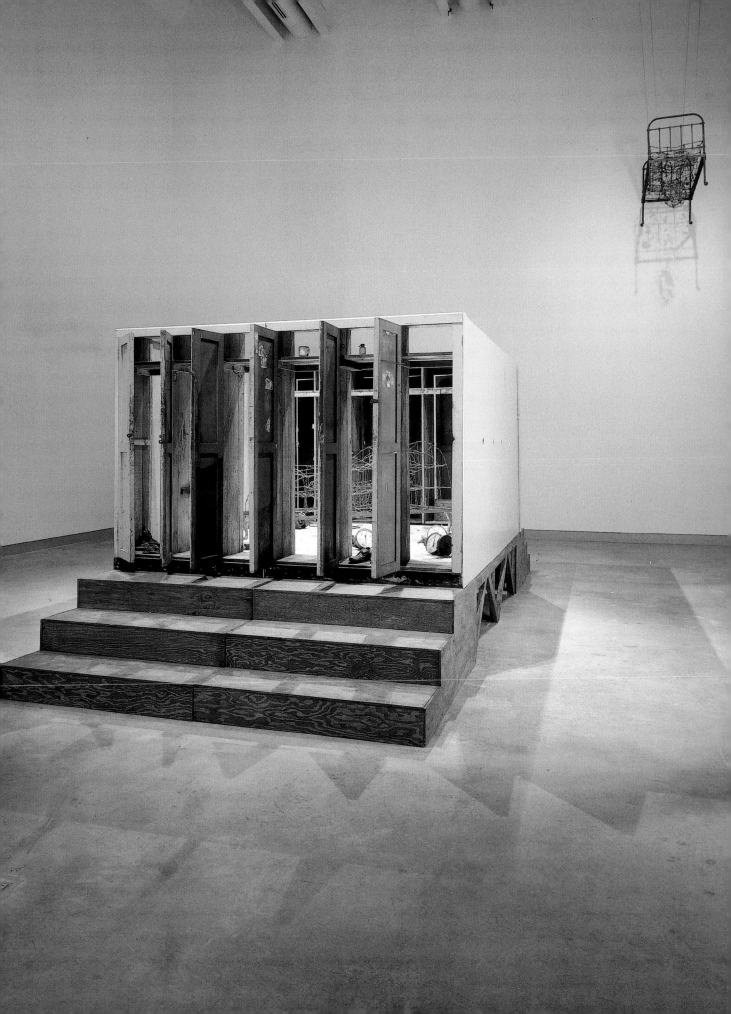

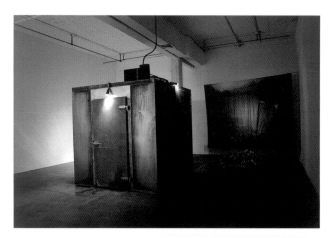

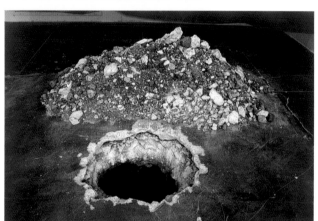

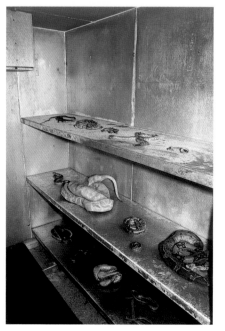

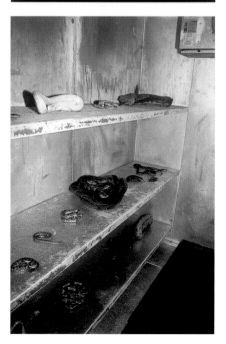

116

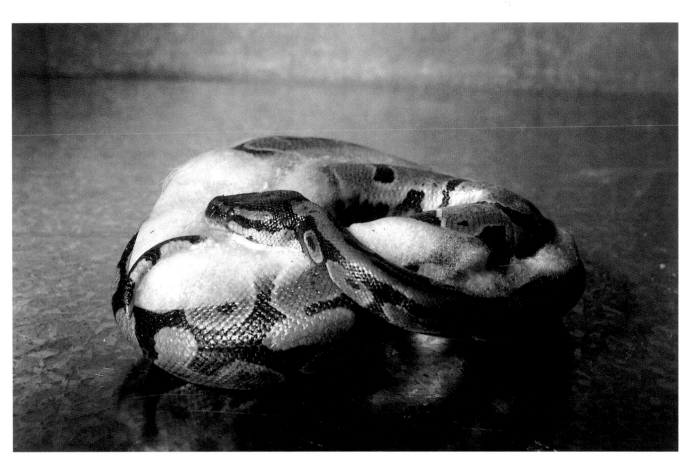

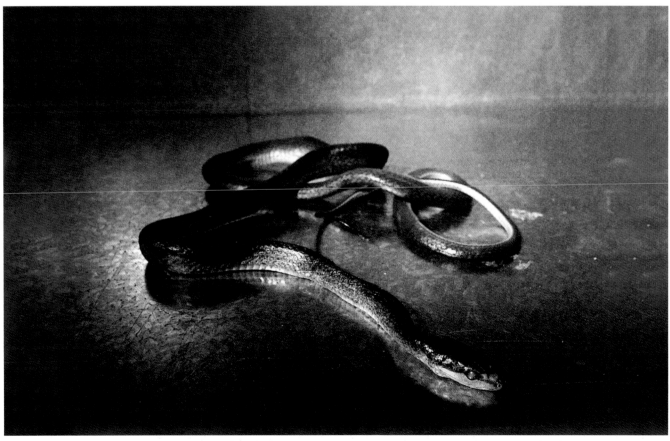

this work perfectly illustrates Cross's ability to ride associative potential at a controlled, deliberate pace, thus ensuring that the uncovering of latent metaphorical power is as much an act of the viewer as it is of the artist.

Around this time her tenure in her loft studio at Foley Street in the inner city came to a somewhat abrupt end as the tide of development reclaimed the building for "mixed residential/commercial" development. While living there, she had purchased a couple of acres on the coast of Galway in the west of Ireland. She came across the land during one of her regular visits to scuba dive in the Atlantic. Now facing Dublin's pulsing real estate market, Cross decided to relocate there and was lucky to be able to secure a house opposite her fields.

Cross's interest in diving and her life beside the Atlantic coast, as happens in so much of her story, has led to a remarkable body of work, from *Teacup* (1997) to *Slab*, produced in 1999. The surface of this work is provided by a mortuary slab onto which is projected the interior of a sea cave, discovered by the artist at the edge of her land. The inert dissection table is animated by the dank

and dripping inside of the cave, a small drainage stream running down its walls and tailing into the plughole of the table.

Diving also created a fascination with jellyfish and through her interest she learned of the naturalist Maude Delap. At the end of the nineteenth century, Delap pioneered research on the morphology and behaviour of the under-studied jellyfish. Living in Valentia Island in Co. Kerry, Delap was one of the first biologists to successfully breed jellyfish in captivity. More accurately, she bred jellyfish in bell-jars in a makeshift laboratory in her own home. With her transportation of nature into the domestic, Maude Delap quickly became one of Cross's *personne trouvé*. Cross and her brother, Tom, a zoologist, won a SciArt Award, a London based scheme to fund collaborative work between artists and scientists. This joint project had many manifestations including a BBC Radio 3 program that examined Cross's fascination with Delap as much as it examined Delap's life itself. *Medusae* was a video installation that was premiered in a disused church in Valentia in 2003 (where Delap's father had been minister). As part of the investigation, Cross travelled to

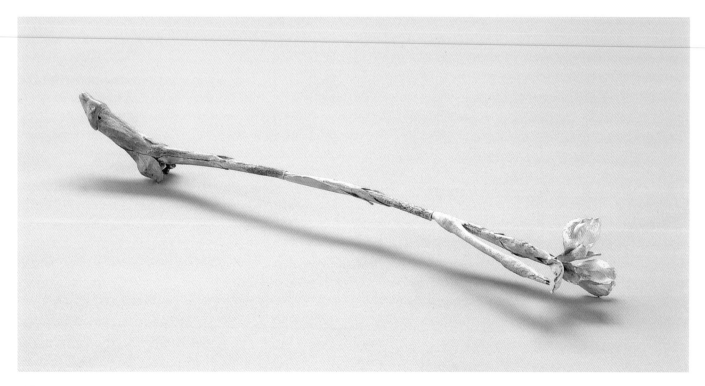

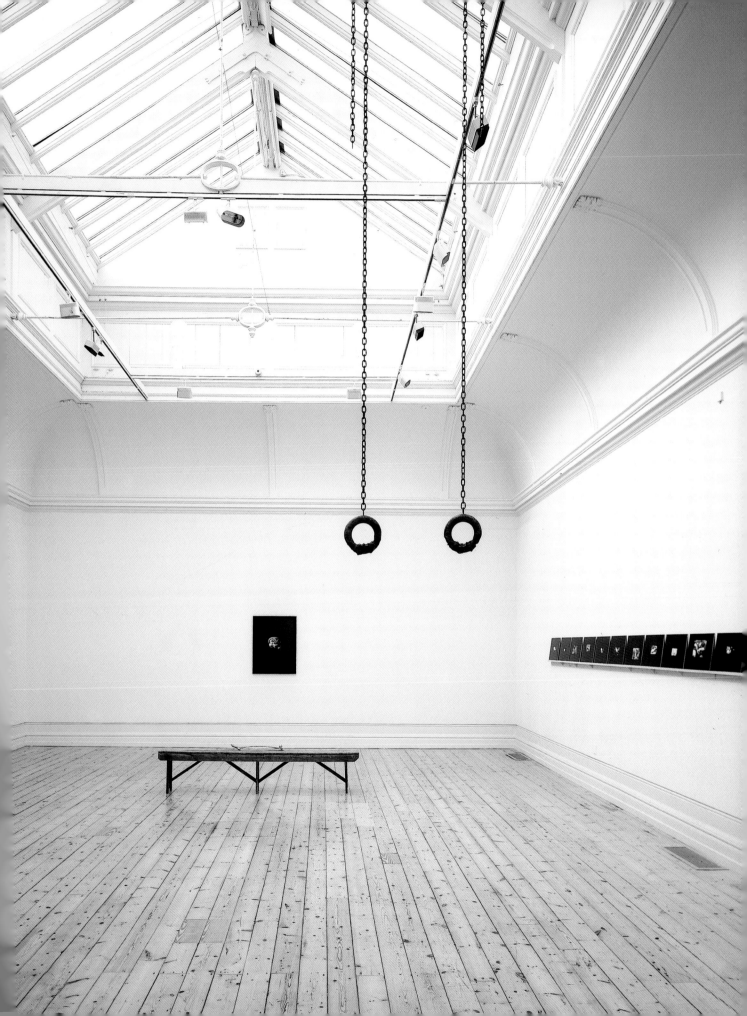

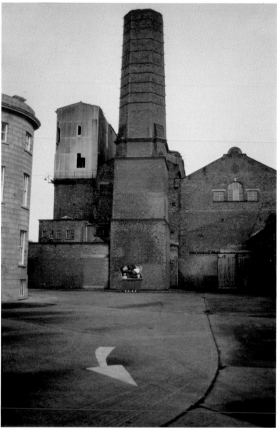
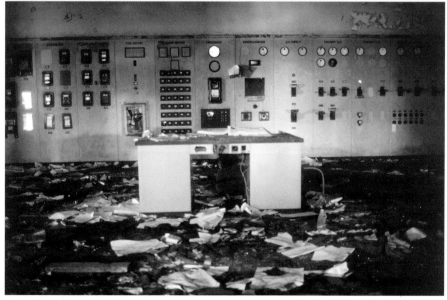

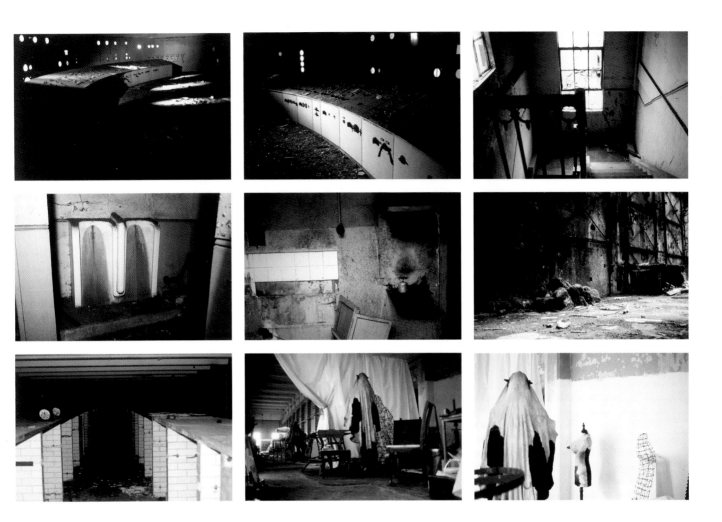

an extraordinary jellyfish lake in the Palau archipelago, Micronesia. The resulting video, *Jellyfish Lake* (2003), arose from what was first intended to be research footage. In the final version, an underwater camera captures the seductive ballet of small white jellyfish moving in azure water. We are then introduced to a floating female nude, head held slightly above the surface. The bare skin and our knowledge of the jellyfish's ability to sting flickers our response from an appreciation of beauty to a sense of empathic endangerment.

While visiting the now derelict house of Delap in Valentia, Cross came across the Slate Quarry. This was once a natural cave that had been extended and broadened as an industrial slate quarry. As the mining diminished, the quarry was turned into a grotto in commemoration of the Marian visitations at Fatima. The combination of nature, industry and religion immediately captivated Cross. In 2004, utilising the unintentional proscenium arch of the quarried cave, Cross produced with the Opera Theatre Company of Ireland, a multi-media presentation of the seventeenth-century work *Stabat Mater* by Giovanni Battista Pergolesi. The performers, dressed in workmen's outfits, sang the devotional prayers accompanied by an ensemble of baroque players. As the performance finished a large screen was mechanically moved forward out of the dark recess of the cave. Music was replaced by the roar of industry accompanied by projected video images that amplified the trinity that Cross had identified—nature, industry, and religion.

Cross's rigorous observation of nature, both human and other, combined with her ability to extract beautiful and complex connections from objects, living and inert, found and made, creates a profound and compassionate poetry on contemporary existence.

"Art is the thing that makes life more interesting than art".[4]

1. In a conversation with the artist, 16 December 2004.
2. Dorothy Cross 96.2, Artpace, San Antonio, Texas, 1996.
3. Ibid.
4. Unattributed quote used by Robert Gober in an interview with Vija Celmins, *Vija Celmins* (London: Phaidon, 2003).

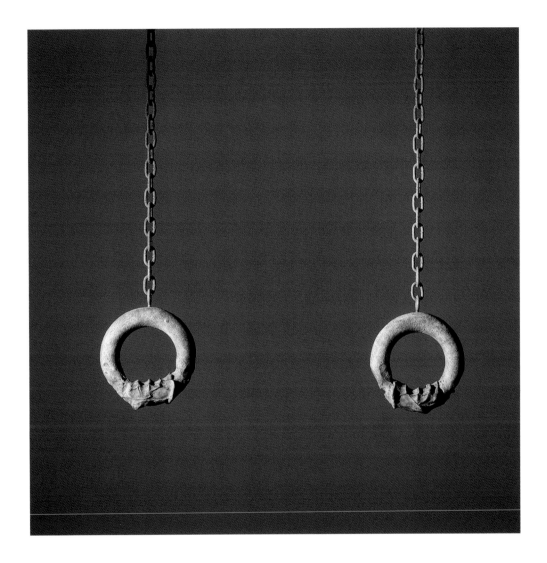

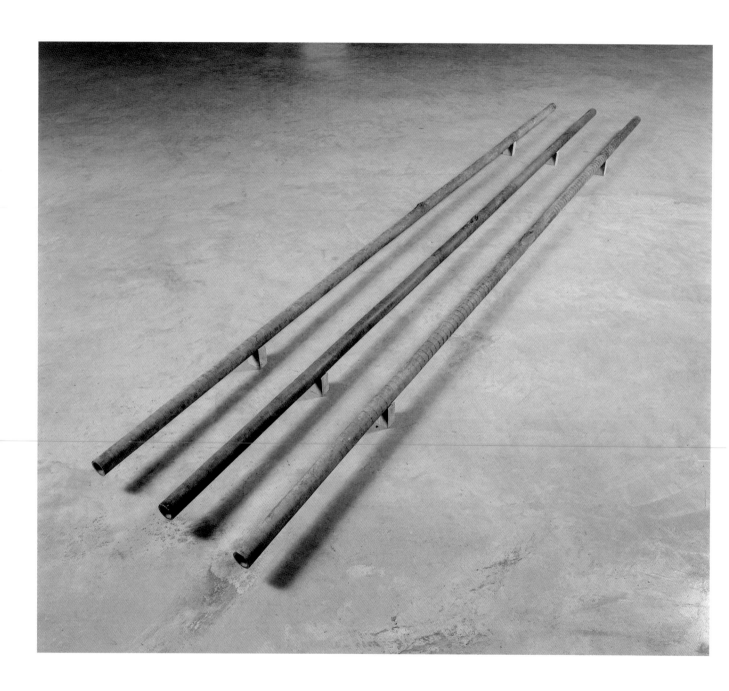

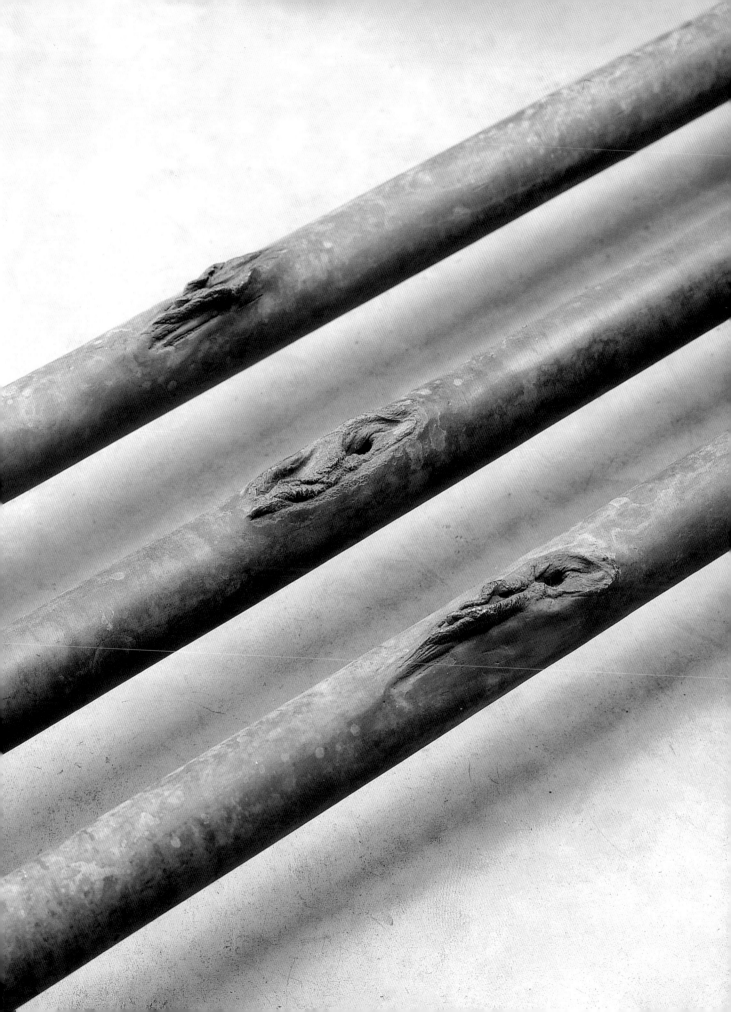

List of Works

Shark Lady in a Ball Dress,
1988
Cast and woven bronze
cm 110x70x70
Collection Hugh Lane
Municipal Gallery, Dublin
Photo credit: John Kellett
p. 29

Ebb, 1988
Installation views, Douglas
Hyde Gallery, Dublin
Photo credit: John Kellett
p. 103

Passion Bed, 1989
Steel wire and sandblasted
wine glasses
cm 170x399x53.5
Collection The Ulster
Museum, Belfast
Photo credit: John Kellett
pp. 108–109

Power House Studio
Studio at the Pigeon House
Power Station Dublin Bay
1990–1994
Photo credit: Dorothy Cross
pp. 120–121

Power House, 1991
Installation view, ICA,
Philadelphia, 1991
p. 114

Control Room, 1991
Control panels: steel, wood,
light bulbs and salvaged
electrical apparatus
cm 104x90x86 each panel
Overall dimensions variable
p. 114

Heart Chair, 1991
Cast iron chair, cast bronze
and steel wire
cm 82x42x56
p. 114

Kitchen Table, 1991
Wood, enamel bowl, steel,
glass test tube, fossilised
shark teeth

cm 90x162x60
Collection Irish Museum of
Modern Art. Purchased, 1991
Photo credit: John Kellett
p. 104

Parthenon, 1991
Wooden lockers, ceramic
tiles, gauges, steel wire, cast
iron
cm 244x625x272
p. 115

Udder Bench, 1991
Wooden bench, cowhide and
cow's udder
cm 91.5x45x24
Courtesy Kerlin Gallery,
Dublin
Photo credit: John Kellett
p. 44 (10.)

*Screen / Ladies Changing
Room*, 1991
Wooden screen, bench, cast
bronze hardhats, cord and
hooks
cm 198.1x213.4x121.9
Courtesy Kerlin Gallery,
Dublin
Photo Credit: John Kellet

Amazon, 1992
Cow skin, teat & Tailor's
dummy
cm 160x36x40 tall
Collection Avril Giacobbi
Photo credit: John Kellett
p. 17

Bull's Eye, 1992
Dartboard, cow's teat and
darts
cm 46x8.5
Courtesy Kerlin Gallery,
Dublin
Photo credit: John Kellett
p. 43 (2.)

Twelve Apostles, 1992
Hand-blown silvered glass
and wooden bench.
cm 30x60x366
Courtesy Kerlin Gallery, Dublin

Photo credit: John Kellett
pp. 54–55

Vaulting Horse, 1992
Wood, cow skin with udder
and saddle
cm 132x143x71
Private Collection
Photo credit: John Kellett
p. 33

White, 1992
Cow skin and teats
cm 234x266
Courtesy Kerlin Gallery,
Dublin
Photo credit: John Kellett
p. 43 (3.)

Balls, 1993
Cow's teats on balls
cm 10x13 each
Private Collection
Photo credit: John Kellett
p. 44 (11.)

Bodhrán, 1993
Cow's udder and wooden
bodhran frame
cm 47x9
Courtesy Kerlin Gallery,
Dublin
Photo credit: John Kellett
p. 45 (18.)

Bust, 1993
Cow's udder and tailor's
dummy
cm 71x38x30.5
Private Collection
Photo credit: John Kellett
p. 44 (8.)

Carved in Stone, 1993
Carved granite, cow's teats
and elastic
cm 30x35 each
Private Collection
Photo credit: John Kellett
p. 44 (12.)

Dish Covers, 1993
Silver-plated dish covers and
cow's udders

cm 23x27x20
Private Collection
Photo credit: John Kellett
p. 42

Freud's Couch, 1993
Wood, cow skin and
Waterford crystal glass
cm 197x131x238
Private Collection
Photo credit: John Kellett
p. 14

Ironing Board 1, 1993
Wooden ironing board and
cow's udder
cm 110x30
Private Collection
Photo credit: John Kellett
p. 45 (13.)

Ironing Board 2, 1993
Wooden ironing board and
cow's udder
cm 110x28
Private Collection
Photo credit: John Kellett
p. 45 (14.)

Ladle, 1993
Silver-plated ladle and cow's
teat
cm 32x10
Private Collection
Photo credit: John Kellett
p. 43 (1.)

*Lay your head upon my
pillow*, 1993
Pillow, velvet and cow's udder
cm 44x83x21
Private Collection.
Photo credit: John Kellett
p. 44 (9.)

Lifebuoy, 1993
Lifebuoy and cow's udder
cm 90 x 12
Private Collection
Photo credit: John Kellett
p. 43 (5.)

Mine, 1993
Wooden box and cow's udder

cm 32x37x37
Private Collection
Photo credit: John Kellett
p. 43 (6.)

Pap, 1993
Guinness bottle and cow's
teat
cm 25x5
Courtesy Frith Street Gallery,
London
Photo credit: John Kellett
p. 22

Saddle, 1993
Saddle, cow's udder and metal
cm 118x56x56
Collection Irish Museum of
Modern Art, Purchased, 1994
Photo credit: John Kellett
p. 43 (4.)

Shuttlecock, 1993
Shuttlecock and cow's teat
cm 19x14x10
Private Collection
Photo credit: John Kellett
p. 45 (15.)

Spurs, 1993
cm 28x14x16 each
Boots, cow's teat and string
Private Collection
Photo credit: John Kellett
p. 41

Up Your Sleeve, 1993
Sleeve ironing board and
cow's teat
cm 53x20x13
Private Collection
Photo credit: John Kellett
p. 45 (17.)

Virgin Shroud, 1993
Cowhide, muslin, silk satin
and metal stand
cm 201x81x120
Tate. Presented by the
Patrons of New Art (Special
Purchase Fund) through the
Tate Gallery Foundation 1995
Photo credit: John Kellett
p. 4

Croquet, 1994
Croquet set and cow udders
Dimensions variable
Private Collection
p. 46

Milking Stool, 1994
Stool and cow's udder
cm 32.5x26
Private Collection
Photo credit: John Kellett
p. 44 (7.)

Pointing the Finger, 1994
Cibachrome prints
Edition of 3
Triptych cm 35.6x35.6 each
panel
Courtesy Frith Street Gallery,
London
Photo credit: John Kellett
pp. 18–19

Rugby Ball, 1994
Cow's udder and rugby ball
cm 30x18
Private Collection
Photo credit: John Kellett
p. 45 (16.)

Stilettos, 1994
Shoes and cow's teats.
cm 25x8x10
Private Collection
Photo credit: John Kellett
p. 36

Bible, 1995
Wooden lectern and Bible
cm 56x43.2x35.6
Private Collection
Photo credit: John Kellett
pp. 56–57

Cuttlefish Rings, 1995
Cuttlefish bones and gilt cast
silver in glazed boxes
cm 30x41x6
Private Collection
Photo credit: Dorothy Cross
p. 122

Iris, 1994–1995
Cast silver and wooden bench

cm 221x27x45
Collection of Hugh Lane
Municipal Gallery of Modern
Art, Dublin
Photo credit: John Kellett
p. 118

Lover Snakes, 1995
Stuffed snakes and cast silver
reliquaries containing snake
hearts
cm 37x14
Courtesy Kerlin Gallery,
Dublin
Photo credit: John Kellett
pp. 52–53

Rings, 1995
Steel chain, cast bronze
rings
cm 16.5 diameter rings,
chains variable
Private Collection
Photo credit: John Kellett
p. 123

Trunk, 1995
Wooden trunk, cotton
knickers and cow's teat
cm 103x60x46
Collection Laura Steinberg
and Bernardo Nadal-Ginard
Photo credit: John Kellett
p. 37

Untitled (Skull), 1995
Black and white photograph
cm 81x61
Edition of 3
Private Collection.
Photo credit: Dorothy Cross
p. 37

Arms, 1996
Cast silver
Edition of 3
cm 75x18 each
Collection of Linda Pace
Installation view Model
Niland Gallery, Sligo
p. 60

*Close your eyes and open
your mouth and see what*

God will give you, 1995–1996
Fifty black and white
photographs
cm 51x38 each panel
Private Collection
Photo credit: Dorothy Cross
Installation view Arnolfini
Gallery, Bristol
pp. 62–63

Kiss, 1996
Cast silver
Edition of 3
cm 4x7x6
Private Collection
Photo credit: John Kellett
p. 111

Mantegna/Crucifix, 1996
Cibachrome and black and
white print on MDF
Edition of 3
cm 76x50 each panel
Courtesy Kerlin Gallery, Dublin
Cibachrome Photo credit:
John Kellett and Marych
O'Sullivan
pp. 58–59

Rugby, 1996
Cibachrome prints
Edition of 3
Diptych cm 37x55 each
Private Collection
Photo credit: Dorothy Cross
p. 23

Strangers on a Train, 1996
Installation for *Side Tracking*
commissioned by Gynaika,
Brussels, Belgium
Photo credit: Dorothy Cross
p. 110

Even, 1996
Installation views, Oriel
Mostyn, Llandudno, Wales
p. 119

Cry, 1996
Installation at Artpace, San
Antonio, Texas
Photo credit: Dorothy Cross
pp. 116–117

Teacup, 1997
Video
3 min loop. Edition of 3
Private Collection
Stills from video
pp. 20–21

Untitled (Snake), 1997
DVD 9 mins
Edition of 3
Stills from video
Courtesy Kerlin Gallery,
Dublin
p. 106

Door, 1998
Wooden door
cm 198x76x5
Courtesy Kerlin Gallery,
Dublin
Photo credit: John Kellett
p. 107

Mollusc, 1998
Mollusc shells and cast silver
cm 9x5 each
Private Collection
Photo credit: Dorothy Cross
p. 38

Pipes, 1998
Cast and industrial bronze
cm 11x313 each
Collection Laura Steinberg
and Bernardo Nadal-Ginard
Photo credit: John Kellett
pp. 124–125

Chiasm, 1999
Offsite Project commissioned
by Project Arts Centre, Dublin
Performed at St. Enda's
College handball alleys,
Galway, May 1999
Photo credit: Dorothy Cross
pp. 76–81

Ghostship, 1999
Documentation of Nissan Art
Project in association with
IMMA, 1999
Photo credit: Ronan McCrea
and Dorothy Cross
pp. 82–87

Slab, 1999
Mortuary slab and DVD
projection 6 mins loop
cm 89x204x77
Collection Laura Steinberg
and Bernardo Nadal-Ginard
Photo credit: John Kellett
p. 68

Candle, 2000
Black and white photograph
cm 76x51
Courtesy Kerlin Gallery,
Dublin
Photo credit: Dorothy Cross
p. 133

Endarken, 2000
DVD 1 minute loop
Edition of 4
Courtesy Frith Street Gallery,
London
Stills from video
pp. 64–65

Eyemaker, 2000
DVD 22 mins
Courtesy Kerlin Gallery,
Dublin
Camera: Belinda Parsons
pp. 70–71

Midges, 2000
DVD 9 mins
Edition of 4
Courtesy Kerlin Gallery
Dublin
Stills from video
pp. 66–67

Silk, 2000
Cibachrome diptych
cm 28x20 each panel
Courtesy Frith Street Gallery,
London
Photo credit: John Kellett
pp. 34–35

Sofa, 2000
Cibachrome prints
Edition of 4.
Diptych cm 65.5x90 each
Courtesy Kerlin Gallery,
Dublin

Photo credit: Dorothy Cross
pp. 6–7

Still, 2000
Unique duratran laminated on
10mm glass
cm 243.9x121
Courtesy Frith Street Gallery,
London
Photo credit: Marych
O'Sullivan
p. 24

Bone Gloves, 2001
Leather gloves and human
index finger bones
cm 56x41x4.5
Private Collection
Photo credit: Dorothy Cross
p. 136

Figure, 2001
Commissioned by Temple Bar
Properties
Stills from video
pp. 74–75

Finger print, 2002
Finger-bones and cast gold
fingerprint
cm 14x2
Private Collection
Photo credit: John Kellett
p. 61

Jellyfish Lake, 2002
DVD 6 mins
Edition of 4
Courtesy Kerlin Gallery,
Dublin
Camera: Loring McAlpin
pp. 96–97

Thimble, 2002
Thimble and walrus whisker
cm 12x1.5
Courtesy Kerlin Gallery,
Dublin
Photo credit: John Kellett
p. 10

Trophy, 2002
DVD 3 mins
Stills from video

Edition of 4
Courtesy Kerlin Gallery,
Dublin
pp. 72–73

Jellyfish Drawings, 2003
Jellyfish on paper
(Physalia, Chironex fleckeri)
Photo credit: John Kellett
p. 99

Jellyfish Pillowcases, 2003
Jellyfish on linen
cm 48x87x20 each
Private Collection
Photo credit: Tessa Traeger
p. 100

Drying Jellyfish
Connemara, 2003
p. 98

Sheet, 2004
Lamda print on watercolour
paper
Edition of 4
cm 183x128
Courtesy Kerlin Gallery,
Dublin
Photo credit: Tessa Traeger
p. 101

Stabat Mater, 2004
Performance of Pergolesi's
Stabat Mater in the Slate
Quarry / Grotto Valentia
Island, Co. Kerry, in
conjunction with The Opera
Theatre Company of Ireland
Photo credit: Loring McAlpin
and Dorothy Cross
pp. 49–51

Sugán Chair, 2004
Sugán chair, cast 9 ct gold
cm 78x47x49
Private Collection
Photo credit: Denis Mortell
p. 8

Whale, 2004
Cibachrome prints
Edition of 4
Diptych cm 53x68 each

Courtesy Kerlin Gallery,
Dublin
Photo credit: Dorothy Cross
p. 143

Other Works

Louise Bourgeois,
Femme Maison, 1945–1947
Oil and ink on linen
cm 91,5x35,5
Courtesy the Artist
p. 12

Meret Oppenheim,
Object (le dejeuner en fourrure), 1936
Fur-covered cup, saucer and spoon
cup cm 10,9 Ø, saucer cm 23,7 Ø, spoon cm 20,2, overall height cm 7,3
Courtesy New York, Museum of Modern Art (MoMa) © 2005
Digital image, The Museum of Modern Art, New York/Scala, Florence
p. 13

Studios
1–3. Studio, Foley Street, Dublin,
1996–2001
4–6. Glasshouse, Co. Wicklow,
1993–1996
7–9. Mullaghgloss, Co. Galway,
2001–present

1

2

3

4

5

6

7

8

9

Biography

1956
Born Cork, Ireland

1973–74
Crawford Municipal School of Art, Cork

1974–77
Leicester Polytechnic, England (BA)

1980–82
San Francisco Art Institute, California (MFA)

Lives and works in Connemara, Ireland

Selected Exhibitions

Solo Exhibitions

2004
Stabat Mater, Slate Quarry, Valentia Island, Co. Kerry

2003
Medusae, (Dorothy Cross and Tom Cross), Church of Ireland, Valentia Island, Co Kerry

2002
The Paradise, Douglas Hyde Gallery, Dublin

Salve, Kerlin Gallery, Dublin

2001
Frith Street Gallery, London

F*igure*, Winter Solstice outdoor projection, Dublin, Commission by Temple Bar Properties, Dublin

Come into the Garden Maude, Fourth Wall, National Theatre, London

1999
Kerlin Gallery, Dublin

Chiasm, Project Arts Centre in Galway

Ghostship Nissan Art Award / IMMA, Dublin

1998
Model Arts Centre, Sligo

Frith Street Gallery, London

1996
Even, Arnolfini Gallery, Bristol

Even, Ikon Gallery, Birmingham

Even, Oriel Mostyn Gallery, Llandudno

Center for the Arts, San Francisco (with David Ireland)

Cry, Artpace, San Antonio, Texas

1995
Inheritance, P.P.O.W., New York

Kerlin Gallery, Dublin

1994
Kerlin Gallery, Dublin

Croquet, Frith Street Gallery, London

1993
Parthenon, Camden Arts Centre, London

Works from *Powerhouse*, Douglas Hyde Gallery, Dublin

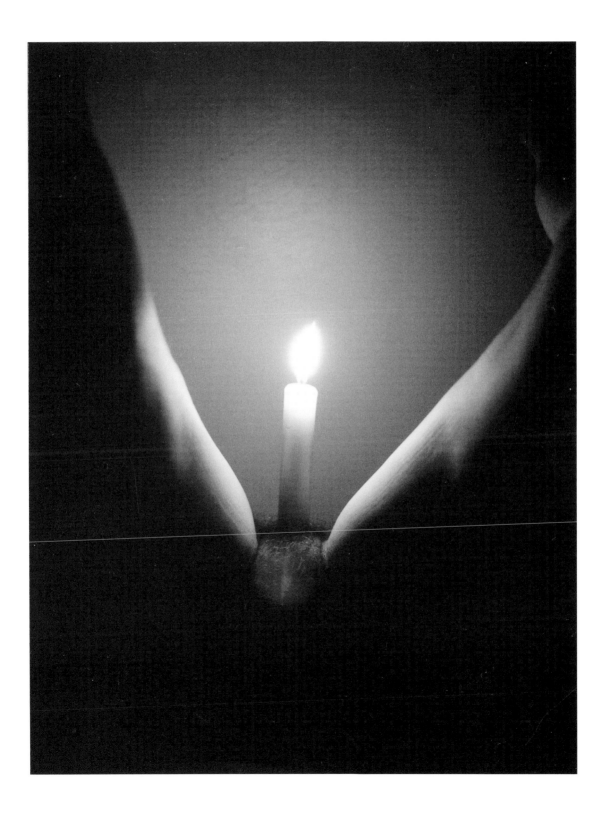

1991
Power House, ICA Philadelphia, USA

1990
Kerlin Gallery, Dublin

1988
Ebb, Douglas Hyde Gallery, Dublin

Octagon Gallery, Belfast

1985
Contraptions, Hendriks Gallery, Dublin

1983
Triskel Arts Centre, Cork

Group Exhibitions

2004
Wonderful, Arnolfini Gallery, Bristol & Cornerhouse, Manchester

Medusa, National Gallery of Victoria, Australia & Magna, Rotterham

Corpus, Limerick City Gallery, Ireland

Public and Private Narratives, IMMA Dublin

Transmit and Transform, Santa Fe Art Institute, New Mexico, USA

2003
Liquid Sea, Museum of Contemporary Art, Sydney

Leopold and Rudolph Blaschka, Grand-Hornu, Hainaut, Belgium & Nottingham Castle Museum, Nottingham

REALISMUSSTUDIO, NGBK, Berlin Chironex fleckeri or Suspended Moments, curated by Frank Wagner

Eire/land, McMullen Museum, Boston

2002
At Sea, Sainsbury Centre for Visual Arts, Norwich

Leopold and Rudolph Blaschka, Design Museum, London & National Glass Centre, Sunderland

In the Freud Museum, Freud Museum, London

A Garden for Zoersal, curated by Edith Doove, Belgium

Metamorphing, Welcome Wing, Science Museum (curated by Marina Warner & Sarah Bakewell)

H2O, Western Gallery, Western Washington University, Bellingham, Washington; Elaine L. Jacob Wayne State University, Detroit, Michigan

Tech/No/Zone, Taipei Museum of Contemporary Art (curated by Ewen McDonald)

2001
At Sea, Tate Liverpool, Liverpool

Irish Art Now: From the Poetic to the Political, Irish Museum of Modern Art, Dublin

The Silk Purse Procedure, Spike Island & Arnolfini Gallery, Bristol

Host Artist, Hastings Museum & Art Gallery curated by Mario Rossi

Aquaria, Oberoesterreichisches Landesmuseu, Linz, Austria & Staedtische Kunstsammlungen, Chemnitz, Germany & Museo D'Arte Moderna, Bologna, Italy & Charlottenborg

Udstillingsbygning, Copenhagen

2000–01
Shifting Ground: Fifty Years of Irish Art, Irish Museum of Modern Art, Dublin

A Way A Lone, A Last A Loved A Long The, Museum of Contemporary Art Zagreb, Croatia

2000
Skin, Cranbrook Art Museum, Bloomfield Hills, MI, USA

Give and Take, Jerwood Space, London

Dorothy Cross/Charles Tyrrell, Fenton Gallery, Cork

Instinct, Bergen Kunstverein, Norway

The Sea & The Sky, Beaver College Art Gallery, Pennsylvania & Royal Hibernian Academy, Dublin

Ghostship, Locus International, Swansea

Art Gallery of Newfoundland and Labrador, Canada; Chicago Cultural Center, Chicago

1999
The Challenge of Power, Limerick City Art Gallery, Limerick

1st Liverpool Biennal of Contemporary Art, Liverpool

Please Touch, Edmund Hubber Projects, The Lighthouse, Glasgow & SCP showroom, Curtain Road, London

Contemporary Art, Arts Council Collection, Limerick City Art Gallery

Physical Evidence, Kettle's Yard, Cambridge

Irish Art Now: From the Poetic to the Political, McMullen Museum of Art, Boston College (1999–2001)

New Media Projects, Orchard Gallery, Derry

Personal Effects: Sculpture and Belongings, Angel Row, Nottingham

0 TO 60 IN 10 YEARS, Frith Street Gallery, London

1998
Mirror Images: Women, Surrealism and Self-Representation MIT

List Visual Arts Center, Cambridge, Mass, USA

Video / Projection / Film, Frith Street Gallery, London

Personal Effects: Sculpture and Belongings, Spacex Gallery, Exeter

Contemporary Art, Arts Council, Dublin & National Gallery of Ireland, Dublin

Figure, Sculpture, Woman, Landesmuseum, Linz, Austria

Opera, Handel Tamerland Centro Cultural de Belem, Lisbon

May Day, PPOW, NewYork

Kerlin Gallery, Dublin

1997
The Model Arts Centre, The Mall, Sligo

IMMA / Glen Dimplex - Artists Award, IMMA, Dublin

Angles Gallery, Santa Monica, California (2 person)

Residue, Douglas Hyde Gallery, Dublin

5th Istanbul Biennial, Turkey

Kvinden, Horsens Museum, Denmark

1996
Fetishism, Brighton Museum and Art Gallery & Nottingham Castle Museum & Sainsbury Centre, Norwich

Summer Exhibition, Kerlin Gallery, Dublin

Frith Street Gallery, London

Laughter Ten Years After, Wesleyan University, USA

Passions Privées, Musée d'Art Moderne de la ville de Paris

New Acquisitions, Tate Gallery, London

IMMA/Glen Dimplex Award Exhibition, Irish Museum of Modern Art, Dublin

1995
Home and Away, Tate Gallery, Liverpool

Side Tracking, Train project, Brussels

Kerlin Gallery, Dublin

Centre for the Arts, Yerba Buena, San Francisco (2-person)

EVA, Limerick City Art Gallery

96 Containers, Docklands, Copenhagen

1994
Bad Girls, ICA London & CCA Glasgow

Art, Union, Europe, Athens/Thessalonika/Corfu,

Denmark/Norrkopings Konstumuseum, Sweden

From Beyond The Pale, Irish Museum of Modern Art, Dublin

Dialogue with the Other, Kunsthallen Brandts Klaedefabrik, Odense

1993
Kerlin Gallery, Dublin (Cross, Kindness, Prendergast)

Other Borders: Six Irish Projects, Grey Art Gallery, New York

Biennale di Venezia, Venice, Italy

Artscape Nordland, Somna Kommune, Norway

EVA Exhibition, Limerick City Art Gallery

1992
EVA, Limerick City Gallery (curated by Lars Nittve)

EDGE Biennale, London and Madrid

Erotiques, AB Galeries, Paris

Welcome Europe, Holstebro Kunstmuseum, Denmark

1991
Strongholds, Tate Gallery, Liverpool & Sara Hidden Museum, Tampere, Finland

EVA, Limerick City Gallery (curated by Germano Celant)

In a State, Kilmainham Gaol, Dublin

Inheritance and Transformation, Irish Museum of Modern Art, Dublin

The Fifth Provence, Contemporary Art from Ireland, Edmonton Gallery, Canada

1990
EVA, Limerick City Gallery (curated by Saskia Bos)

Volm, Tokyo, Japan

Irish Art of the Eighties, Douglas Hyde Gallery, Dublin

Artpark, Lewiston, New York (project: Slippery-Slope)

1989
Eclipse, PS1, New York

Open Studios, PS1, New York

1988
A Sense of Place, Battersea Arts Centre, London

1987
SADE, Crawford Gallery, Cork

Irish Women Artists, Douglas Hyde Gallery, Dublin

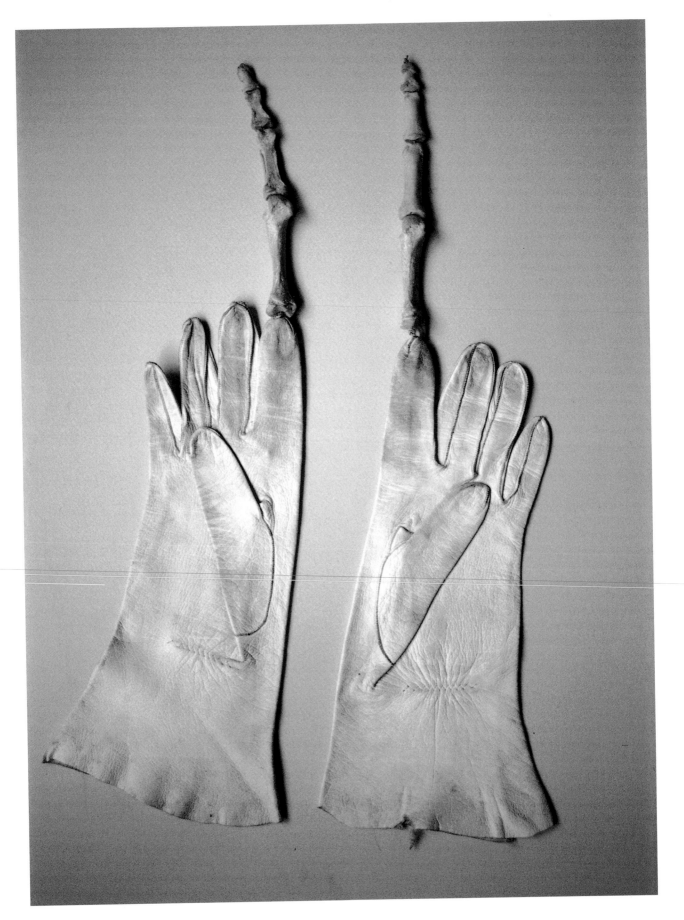

1986
GPA, Emerging Artists Exhibition, RHA Gallery, Dublin

Volm, Tokyo, Japan

Awards

2004
Gulbenkian Project Grant, *Stabat Mater*

2000
SCIART Research and Development Project Award, Wellcome Trust

Gulbenkian Foundation, Arts Council of Great Britain, British Council

1999
Nissan Public Art Project/Irish Museum of Modern Art Award, *Ghost Ship*, Scotsman's Bay, Dublin

1994
Aosdána, Ireland

1992
EVA Open Award, Limerick

1991
Arts Council Bursary

O'Malley Award, Irish American Cultural Institute

1990
EVA Open Award, Limerick

Martin Toonder Award, Ireland

Pollock-Krasner Award, New York

1988
PSI Studio Scholarship, New York

1984–86
Arts Council Bursaries

Opera

2004
Stabat Mater, with Opera Theatre Company, Slate Quarry, Valentia Island, Ireland

2003
Tamberlane, 100 Days Festival, Centro Cultural de Belem, Lisbon with Opera Theatre Company

1997
Tamberlane, Melbourne Festival with Opera Theatre Company

1994
Design for Opera Theatre Company of Ireland production of Songs *of Poems of Emily Dickinson (Coplans) and Diary Extracts of Virginia Wolfe* (Argento), The John Field Room, National Concert Hall, Dublin

1992
Set and Costume Design for *Tamberlane*, Opera Theatre Company

Ireland, Kilmainham Gaol, Dublin, Theatre Royal, Wexford, Cork

Opera House, St Columbs Theatre, Derry and Siamsa Tire, Tralee

Selected Bibliography

2005
Gone by Robin Lydenberg, McMullen Museum, Boston

2003
"Dorothy Cross," essay by Robin Lydenberg, *Contemporary*, Issue 01, January
"Journeying to other worlds: Liquid Sea,", Kate Davidson, *Art Monthly Australia*, Issue 161, July

2002
Mystic, catalogue for the exhibition, Massachusetts College of Art, essay by David D. Nolta, 2003
"Experiment: Conversations in Art and Science," edited by Bergit Arends and Davina Thackara, The Wellcome Trust
"Figure," published in relation to outdoor film installation in Temple Bar, Dublin, Published by Temple Bar Properties, essay by Francis McKee
Leopold and Rudolf Blaschka, ed. James Peto and Angie Hudson, Futura Printing, London

2001
The Silk Purse Procedure, exhibition catalogue, curated by Claire Doherty and Catsou Roberts, Arnolfini and Spike Island, Bristol, 2001
Martin Herbert, "The Deep Blue Yonder," *ArtReview*, Vol. LIII, July/August 2001, pp. 32–37

2000
"Strange and Charmed" *Science and Contemporary Visual Art*, edited by Sian Ede
"Instinct" (Open, Intimate, Closed Rooms), Bergen Kunstverein, Norway, Whitney Chadwick and Astrid Morland

1999
"Personal Effects" (Sculpture and Belongings), by Paul O'Kane, *Contemporary Visual Arts* No. 21
"Memory Vessel," by Ray Ryan, Blueprint no. 158
Irish Art Now: From the Poetic to the Political (independent curators international) IMMA, Essays by Declan MacGonagle, Fintan O'Toole and Kim Levin
Skulpturelandskap Nordland (Artscape Nordland Project) Maaretta Jaukkuri

1998
Mirror Images: Women, Surrealism and Self-Representation, edited by Whitney Chadwick, MIT Press
Sculpture, Figure, Woman, Landesgalerie, Austria
Physical Evidence essay by Simon Wallis, Kettles Yard Currah, Mark; *Video, Projection, Film*, Time Out, June 10–17, p. 47

1997
Art Monthly, Profile by Libby Anson, February issue
On Life, Beauty, Translations and Other Difficulties, 5th Istanbul Biennial

Artforum, review Sligo Model Arts Centre show, Caoimhín Mac Giolla Léith, October

1996
even, catalogue with essays by Tessa Jackson & Paul Bonaventura (Arnolfini, Bristol)
Women, Art and Society by Whitney Chadwick (Thames and Hudson)
Feminism & Contemporary Art, the Revolutionary Power of Women's Laughter by Jo Anna Isaak
The Addition and Subtraction of Skin, Centre for the Arts, San Francisco, essay by René de Guzman

1995
Fetishism, Visualising Power and Desire, catalogue, essay by Roger Malbert
Circa, review of IMMA/Glen Dimplex by Medb Ruane, No. 72
IMMA/Glen Dimplex Award catalogue
Artforum, review of PPOW exhibition, New York by Ingrid Schaffner, Sept issue
Kunstbeeld, article by Rob Peree, issue 9
Laughter Ten Years After, essay by Jo Anna Isaak
Art in America, article on Irish Art by Judith Higgins, December issue

1994
Art, Union, Europe, catalogue essay by Jaki Irvine
Dialogue with the Other, catalogue, Odense, Denmark
From Beyond the Pale, Irish Museum of Modern Art
Art Monthly, review of 'Croquet', Frith Street Gallery, London, September issue

1993
Artforum, feature on Irish artists by John Hutchinson, May issue
Venice Bienniale '93 catalogue, essay by Declan McGonagle
Circa Magazine, "Irish Art in New York", by Anna O'Sullivan, Issue no. 64
Sonsbeek '93, catalogue, Arnhem, Netherlands
Bad Girls, catalogue, ICA, London, essay by Cherry Smyth
Art in America, "Three Installation Artists; News from London", Lynn McCritchie, Oct

1992
'EDGE' Biennial, catalogue, essays by Suzi Gablik, Carolyn Christov-Bakargiev,
Jean Fisher and Jose Lebrero Stals
"Welcome Europe", *European Art*, (catalogue for all EEC countries); essays in Irish section by Jesper Knudsen and Caoimhín Mac Giolla Léith

1991
Strongholds, New Art from Ireland, Tate Gallery, Liverpool and Sara Hilden Museum, Finland, Catalogue text by Penelope Curtis

A New Tradition Irish Art of the Eighties, essays by John Hutchinson, Joan Fowler, Aidan Dunne and Fintan O'Toole
Power House, ICA, Philadelphia, catalogue essay by Melissa Feldman

1991
The Fifth Province, Edmonton Art Gallery, Canada, essays by John Hutchinson, Jamshid Mirfenderesky, Elizabeth Kidd and Joan Fowler

1988
Ebb, Douglas Hyde Gallery, Dublin, essay by Joan Fowler

1987
Irish Women Artists, the National Gallery of Ireland and the Douglas Hyde Gallery, Dublin, catalogue text by Aidan Dunne, John Hutchinson and Joan Fowler

Design
Gabriele Nason

Editorial Coordination
Emanuela Belloni
with
Filomena Moscatelli

Editing
Emily Ligniti

Copywriting and Press Office
Silvia Palombi Arte&Mostre, Milano

Web Design and Online Promotion
Barbara Bonacina

Cover
Jellyfish Lake *(detail)*, 2002

Photo credits
Dorothy Cross
Russell Kaye
John Kellett
Loring McAlpin
Ronan McCrea
Denis Mortell
Marych O'Sullivan
Dr. Jamie Seymour
Tessa Traeger
© Photo RMN/ © Herve Lewandowski
The Art Institute of Chicago
The Museum of Modern Art, New York/Scala, Florence

Irish Museum of Modern Art/
Áras Nua-Ealaíne Na hÉireann
Royal Hospital, Military Road,
Kilmainham, Dublin 8
Tel + 353-1612 9900
Fax + 353-1612 9999
e-mail info@imma.ie
www.imma.ie

Edizioni Charta
via della Moscova, 27
20121 Milano
Tel. +39-026598098/026598200
Fax +39-026598577
e-mail: edcharta@tin.it
www.chartaartbooks.it

Printed in Italy

Published on the occasion of

Dorothy Cross

Irish Museum of Modern Art
3 June – 11 September 2005

Curator
Enrique Juncosa (Director)

Editor
Seán Kissane (Curator Exhibitions)

I would like to thank Enrique Juncosa and the Irish Museum of Modern Art for inviting me to show these works—a selection from many diverse locations and times—and all the staff at IMMA, especially Seán Kissane and Vanessa Berman who worked closely with me and would not let anything fall through the net. Giuseppe Liverani at Charta for making this book. Marina Warner, Patrick Murphy, Ralph Rugoff and Enrique Juncosa for their words which beautifully navigate previously uncharted works.

All art arrives unexpectedly and many people have helped me throughout the years: opera singers who sang in horizontal rain, friends who held cameras in lakes full of jellyfish, brilliantly skilled people who photograph, edit, cast, skin cows upside down, blow glass eyes and captain lightships. The Kerlin and Frith Street galleries for harbouring the work, and especially those who have the faith to fund ideas, who want art to exist and lend their passion until it does. My parents for an extraordinary childhood—being brought up by the sea and then years spent with my brother and sister swimming competitively in pools covering immense distances which led to diving under Antarctic icebergs.

I now live in a place where I may encounter a whale washed up on a beach, the gap between the two [art] worlds seems less defined and the rare moments when they merge more frequent.

Dorothy Cross, May 2005

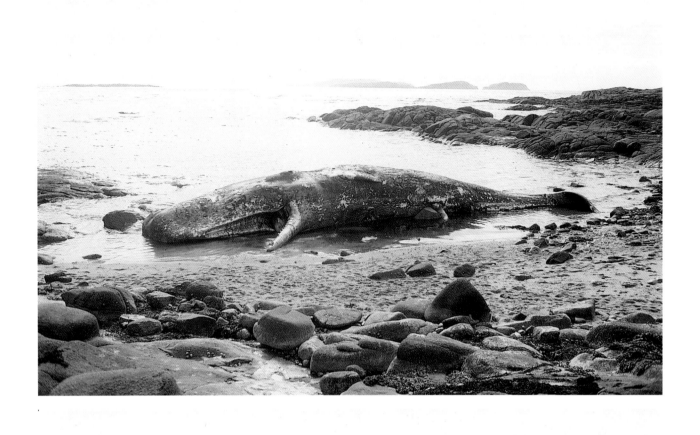

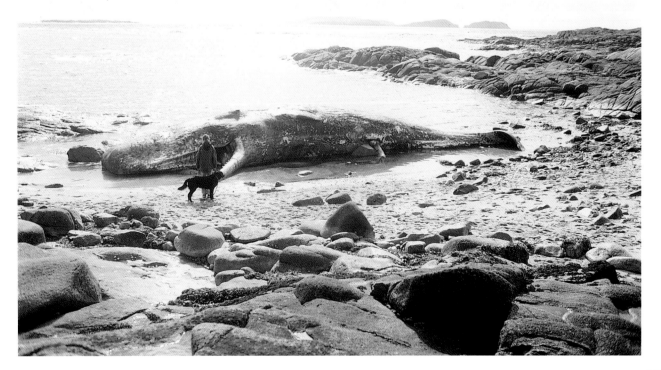

To find out more about Charta, and to learn
about our most recent publications, visit

www.chartaartbooks.it

Printed in Italy
for Edizioni Charta
May 2005